BRINGING TEXTURES TO LIFE

BRINGING TEXTURES TO LIFE

BRINGING TEXTURES TO LIFE

JOSEPH SHEPPARD

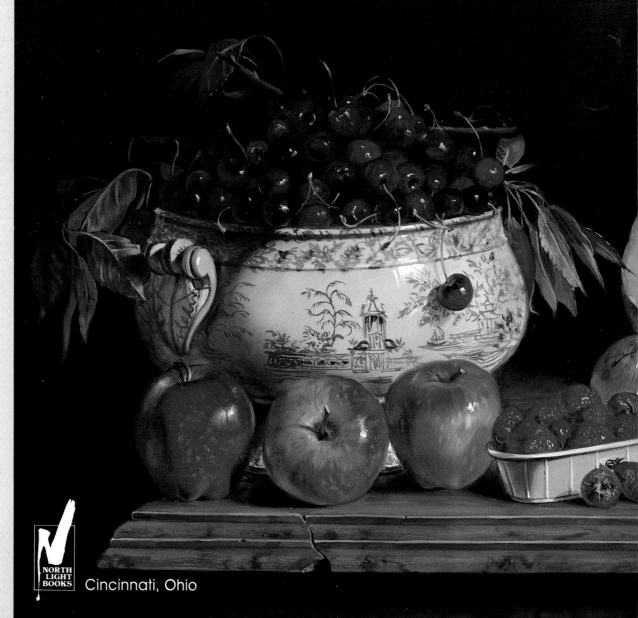

NORTH LIGHT BOOKS

Cincinnati, Ohio

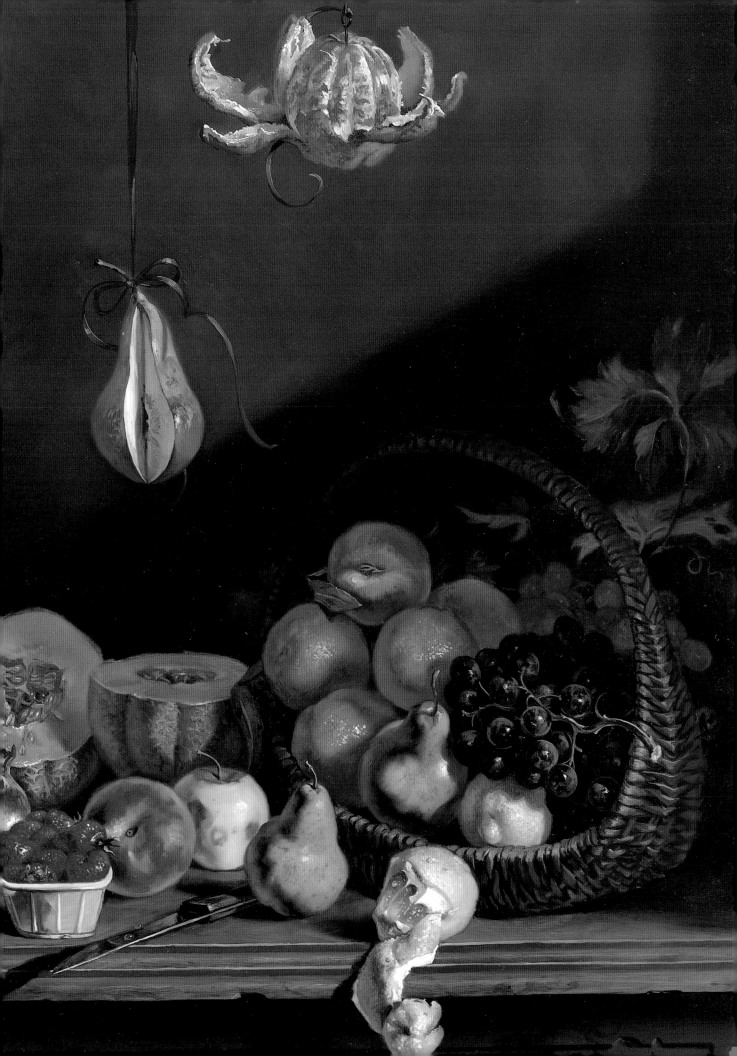

About the Author

Joseph Sheppard attended the Maryland Institute of Art, where he studied with Jacques Maroger, the former technical director of the Louvre and reformulater of the painting medium used by the Old Masters. He has received numerous awards, including a Guggenheim Traveling Fellowship. His work is in many prestigious collections throughout the United States and he has received several major commissions for murals in Baltimore and Chicago. He is the author of several art instruction books and until 1976, he taught drawing, painting, and anatomy at the Maryland Institute of Art. He is a member of the Allied Artists of America, the Knickerbocker Artists, New York; and the National Sculpture Society. Mr. Sheppard resides in Pietrasanta, Italy, where he maintains a studio.

97 96 95 94 93 5 4 3 2 1

First published in 1987 in New York by Watson-Guptill Publications, a division of Billboard Publications, Inc., 1515 Broadway, New York, N.Y. 10036.

Library of Congress Cataloging-in-Publication Data
Sheppard, Joseph, 1930–
 Bringing textures to life.
 Includes index.
 1. Still-life painting—Technique. 2. Texture (Art)—
Technique. 3. Realism in art. I.Title.
ND 1390.S54 1987 751.4 86-28257
ISBN 0-89134-485-3

Designed by Bob Fillie
Graphic production by Hector Campbell

I would like to dedicate this book to my aunt Frances Edna Hall, who took me to the Walter's Art Gallery when I was ten years old and showed me my first authentic oil painting. I would also like to express my thanks to my wife, Nina, who with patience and thoughtful commentary helped me paint the ten paintings for this book.

CONTENTS

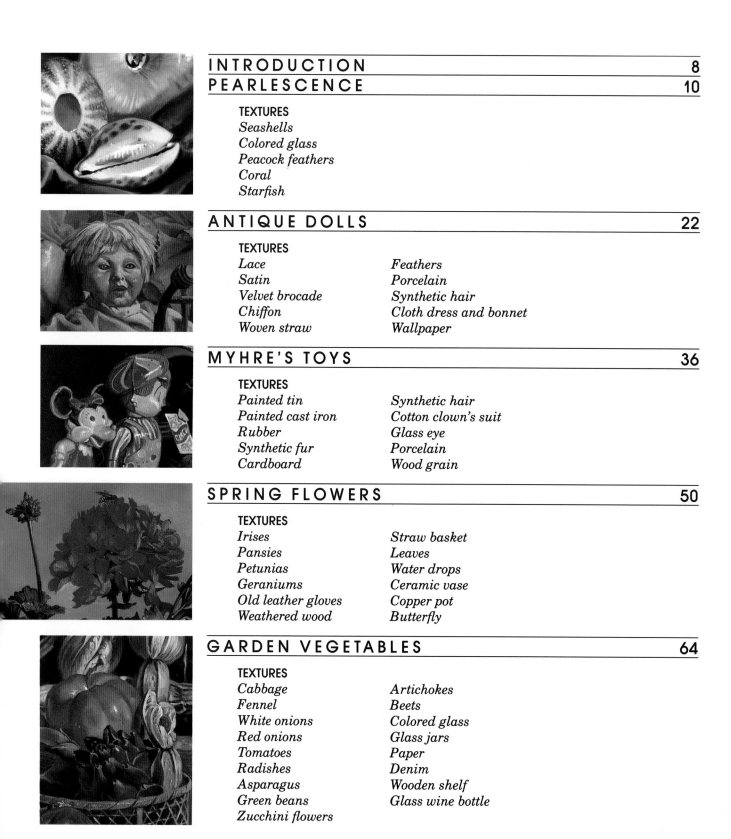

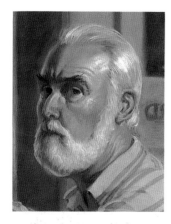

From the beginning of Western painting in the eleventh and twelfth centuries down through the nineteenth century, a common language was used by artists. When a young student arrived at a master's studio, he would be taught how to render objects and textures as well as how to draw. Each texture had its own rules of procedure. The student would memorize this procedure much like a child learns how to read and write. Once he had the mastery of this vocabulary, he could take this knowledge and make a painting.

The student or professional painter never feared that these formulas would deter him and make his work commonplace; instead he realized that mastering these skills freed him from slavishly copying life and gave him the ability to create from the imagination and still seem true to life.

Van Eyck painted a gold goblet with painstakenly detail, and a century later Rubens, using the same formulas, painted the same gold goblet with broad sweeping strokes. Depending on the creative talent and personality of the individual artist, the painting produced became a unique work of art. No one would say that Shakespeare and Hemingway wrote alike, even though they both used the same language. So it was with the techniques of drawing and painting.

In this book I have tried to present as many varied textures as possible. I have used still life as a format because this genre lends itself to placing many objects together for close scrutiny in one picture. Instead of painting one silver teapot and showing you step-by-step how to paint silver, I have purposely created very full compositions with as many objects as possible.

All of the paintings in this book are painted with one natural light source. The old masters discovered that one light source, preferably high and slightly to the front and side, gives the best illumination for creating depth and form. Most of these painters used a light source that would give them three-quarters light and one-quarter shadow on their objects.

Basically three-dimensional forms are divided into two major areas, the light area and the shadow area. The light area in turn is divided into two areas: a predominant area called the middletone, where the color of the object is most apparent; and the highlight, which is the brightest section in the area of the middletone. The highlight is closer to the light and distinctly lighter than the middletone.

The area turned away from the light is the shadow area and is also divided into two tones: a darker tone called the shadow accent, which is next to the middletone; and a paler tone called the reflected light, which is light that bounces off other objects or off the background and back to the subject. It is important to remember that reflected light is never as bright as the areas of light.

Finally, there is a tone called the cast shadow, which is the shadow cast by one form on another. It is darkest where it abuts the object that casts the shadow. As the cast shadow recedes from the object, the tone grows paler, softer, and more diffused. The darkest tone in the shadow is comparable in value to the shadow accent, while the paler tone in the cast shadow would be comparable to the reflected light.

To summarize light and shade, proceeding in order of value from the very lightest tones to the very darkest ones, there is the highlight, the middletone, the reflected light, the cast shadow, and the shadow accent.

It is almost impossible to paint fine pictures in oil without using some kind of medium. I find the commonly used mixtures of raw linseed oil and turpentine inadequate as a medium because they tend to make colors muddy, they are too thin and tend to run, and they dry to a dull finish. Commercial mediums are also available. I use Maroger medium because it has the properties I need, such as consistency, a fast drying time, and the ability to combine well with colors.

An important quality the painting medium must have is that it has to hold the wet paint in place on the painting surface while it is blended with a dry brush. Once the colors are softly blended together, the edges of the rendered forms will look diffused but the basic form will remain and not be lost.

The following is a list of some of the better mediums:

Maroger medium
There are two varieties of this medium: the Italian, which has a matte finish; and the Flemish, which is glossy. I use the Flemish medium. Maroger medium can be obtained from John Bannon, 4011 Javins Drive, Alexandria, Virginia, 22310.

Roberson's medium
A British product that is easy to find in the United Kingdom, but it may not be easy to find in the United States. You can order it from C. Roberson & Company Ltd., 71 Parkway, London NW1 7QJ, England.

Medium Flamand and Medium Venetian
These two mediums are manufactured by the French firm LeFranc and Bourgeois and sold throughout the world.

Taubes Copal painting medium
Manufactured by Permanent Pigments and widely sold throughout the United States.

Winsor & Newton alkyd medium
Sold in three consistencies: a fluid form called Liquin; a gel called Win-Gel; and a thicker gel called Oleopasto. These products are easy to find in most art stores.

Many of you will be using a

commercially prepared board or canvas. They come with a ready-made white ground that I have generally found unsuitable, since they are too absorbent. A good painting surface is one that is nonabsorbent, has sufficient "tooth" (or texture) to take the brushstroke, and allows the paint to hold fast and dry well.

To improve commercially prepared surfaces, you need to paint on an additional layer of acrylic gesso to make the surface nonabsorbent. You can buy gesso in jars or cans in any art supply store. The thick, white pasty compound can be diluted with water to any consistency you prefer. Acrylic gesso is flexible enough for use on canvas, as well as on a panel.

Once you have painted in the initial layer and let it dry, I suggest another coat to give the surface a tone. This second coat can be tinted with black or with one of the umbers or ochres. I use one part acrylic matte medium (Liquitex) and one part water that has been tinted with either acrylic or watercolor paint. When the surface is bone dry, it is ready for paint.

Of course, if you choose to stretch your own canvas using unprimed canvas cloth or prepare an uncoated Masonite board, you can also use acrylic gesso to prepare the surface. The two coats are sufficient for the already smooth surface of the Masonite, but you'll need several coatings for the unprimed canvas.

Most of the paintings in this book are painted on Masonite panels; but *Sculptor's Studio* (page 104) and *Painter's Studio* (page 116) are painted on linen canvas. The paintings vary somewhat in size but are all approximately 30″ × 36″ (76.20 × 91.44 cm). The objects rendered are more or less life-size.

Many of the old masters used small palettes and just a few colors. They did not need large palettes because they did most of their mixing directly on the canvas or panel on which they were working. They simply placed a small amount of color on the canvas, then added a small amount of another color to the painting surface, and finally mixed them together with the brush as they painted. I recommend that you try this if you are not in the habit of painting this way—your colors will look livelier.

The colors that I use in the demonstrations in this book are commercial tube colors and can be bought in any art store. I recommend only those that have been ground in linseed oil, which will be indicated on the tube. I consider the following colors most useful:

alizarin crimson
burnt sienna
burnt umber
cadmium red
cadmium yellow
chrome yellow
ivory black
Naples yellow
Prussian blue
raw sienna
raw umber
rose madder
red ochre
Thalo blue
ultramarine blue
vermilion
white lead (flake white)
yellow ochre

You will notice that no greens are included in the list. This is because a whole range of excellent greens can be mixed with combinations of yellow and blues, or yellows and black. Two important colors are irreplaceable: white lead (flake white) and ivory black. White lead is an absolute necessity: no other white has comparable body or opacity. Ivory black is recommended because it is transparent, an essential quality for the techniques of these texture formulas.

Starting from left to right my palette is laid out with white, yellows, reds, browns, black, and blues. I place my medium, which has the consistency of jelly, in the center of the palette and use it to dilute my colors, which I place around the top edge of my palette.

I find it extremely important to apply a thin coat of medium over the painting surface when starting a second sitting. This thin coat enables the paint to blend in over the first dry coat and not show a break between the two sittings. A coat of medium is applied before each additional sitting.

I use both bristle and soft-hair sable brushes. The larger the brush, the easier it is to cover a surface. It is important to have a lot of good brushes of different sizes—

and to keep them clean. After painting, wipe the paint off the brushes with a cloth or paper towel, then wash them in mild soap and warm water. Do not simply rinse brushes in turpentine; you'll ruin the bristles.

As you paint, each color should be assigned its own brush, even several brushes of different sizes. Only by doing this can you paint one color over another without creating mud.

In every demonstration there are many references to dry blending brushes. I find the best "blenders" are regular house painting window trim brushes. You can find these either in your local paint or hardware store. Blending brushes should be made out of pig's bristles and should be washed several times before using to get rid of loose hairs. You can buy these in a variety of sizes and you can never have too many. It is important to keep the blending brush wiped clean and dry. If it starts to pick up paint, it will no longer blend but smear.

To get the most out of this book, I suggest that you try the recommended mediums, colors, and brushes, paying special attention to the method of preparing canvas or panel. Study each demonstration step-by-step and try a similar procedure in a painting of your own. Substitute your own objects, or if you prefer copy a part of a painting in the book. The important thing is not your finished picture but the knowledge and experience you gain from working through these techniques.

JOSEPH SHEPPARD

PEARLESCENCE

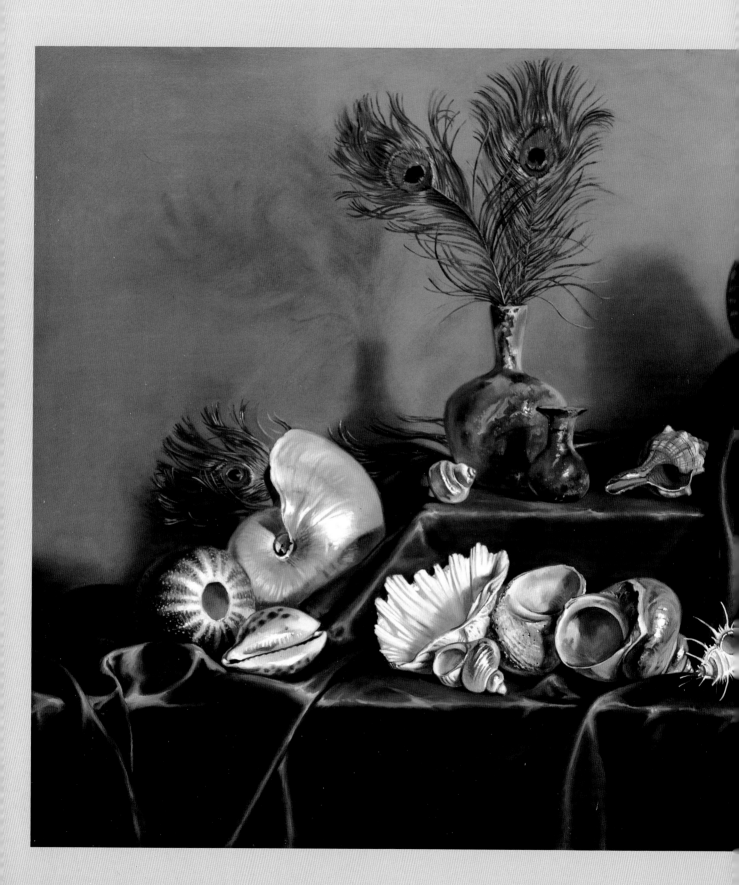

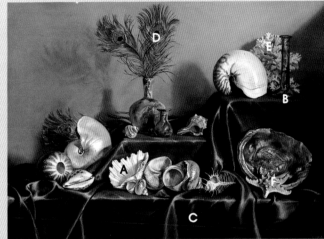

PEARLESCENCE, oil on panel, 39″ × 31½″ (99.06 × 80.01 cm).

TEXTURES

A. *Seashells*

B. *Colored glass*

C. *Satin drapery*

D. *Peacock feathers*

E. *Coral*

F. *Starfish*

COMPOSITION SKETCHES

1. On white paper I make a rough drawing using Conté crayon. I decide to arrange the objects on two levels in order to avoid excessive overlapping. I place the large shells first.

2. In this sketch I add a third level to give more variety to the composition.

3. Each group of objects is rearranged to form a more distinct silhouette as well as a more interesting design.

4. I improve the folds in the drapery and move the shells around slightly until the setup pleases me.

THE UNDERPAINTING

5. Using the composition sketches as a guide, I sketch in an outline on a prepared Masonite panel with pencil. However, something about the composition displeases me. After looking at the sketch for a while, I understand the problem and conclude that the composition is too low.

6. To correct and raise the composition, I draw in a new outline using a mixture of burnt umber and painting medium. With this same color and a no. 6 round bristle brush, I scrub in the shadows of the drapery and shells using very little paint.

7. Using a large brush, I paint in the light area of the background wall with a mixture of yellow ochre and black. By adding just a touch of white to this mixture, I very subtly lighten the background nearest the cast shadows. The cast shadows are painted in using another large brush with a mixture of black and burnt umber. I work the edges of shadow into the background color. To indicate its distance from the light source, I darken the background on the left side.

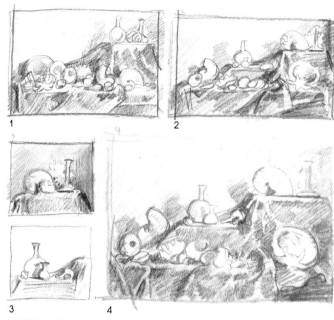

1

2

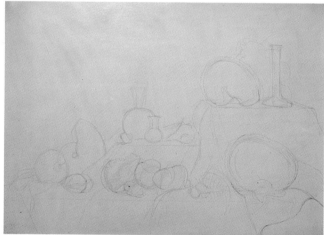

3

4

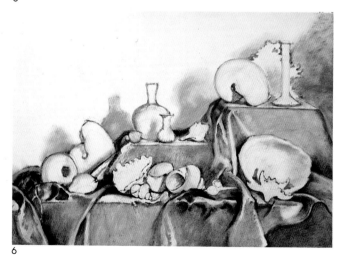

5

6

8. I blend the background with a dry, flat bristle brush, called a blending brush, being careful not to lose the shapes of the shadows.

9. A light gray is mixed using white, a touch of burnt umber, and black. I paint the light areas of the nautilus shell with this gray. The paint is applied thinly by putting pressure on the brush, not by adding a lot of medium. Then using the same colors, I mix a darker gray and paint in the shadow areas of the shell.

10. The glass vase is painted in with a middle gray tone. Using light and dark grays, I lay in the coral skeleton in the background to indicate areas of light and shadow. I blend these tones together with a blending brush to smooth them out and also to keep a soft edge between the coral and the background.

11. I choose a dark gray to contrast with the lighter shells and glass vase. Then with a small sable brush, I draw in the major forms of the shell with dark gray.

12. Depending on the nature of the light or the local color, each object in this picture is painted with either a cool or a warm gray. The cool grays are mixed with white and tinted with black or one of the blues. The warm grays are tinted with burnt umber or yellow ochre. It's important to keep the light areas keyed low. The surfaces of shells and vases are blended with a dry blending brush. Here, I paint in the light and shadow of the two small shells on either side of the glass vases. These shells and all of the objects that touch the background are painted in while the background is still wet so that they can be blended and their edges fused with the background. This soft-edge effect, called "sfumato," creates a three-dimensional effect as opposed to the cut-out look of a hard edge.

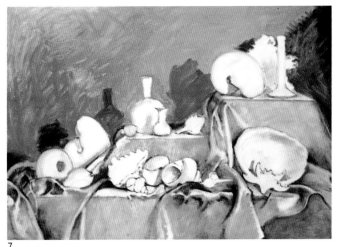

7

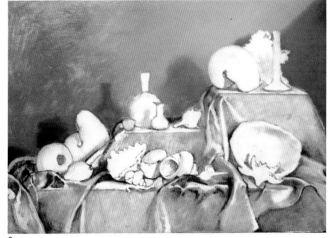

8

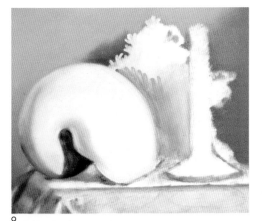

9

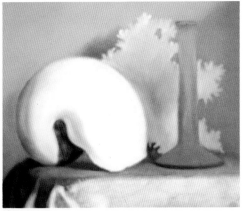

10

11

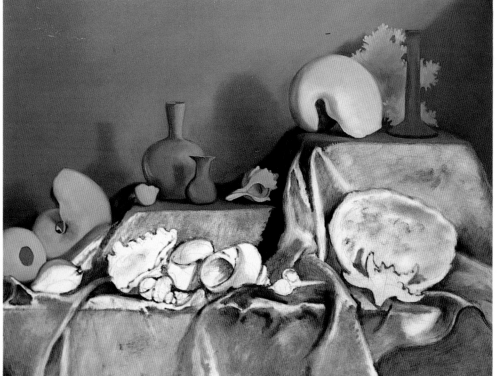

12

Keeping soft edges around adjoining objects helps create a three-dimensional effect.

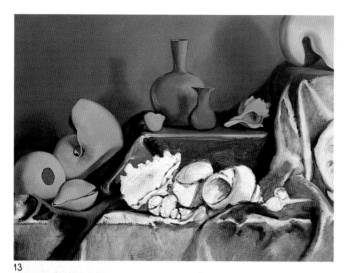

13

13. Using a small sable brush, I define the shape of the shell to the right of the vases with a dark gray. For contrast, I paint the drapery quite dark with the same mixtures of white, black, and burnt umber that have been used for the background.

14. Notice in the lower middle section of the picture I began painting the drapery with bold brushstrokes of gray and black and large brushes to explain the forms of the drapery. Then, as can be seen on the left side of the drapery, I used a blending brush to create the lustrous smooth look of satin.

15. The shells in the lower middle area are painted using the same procedure used to render the other shells. The rest of the drapery is boldly painted in.

16. All of the drapery is blended in, and I lay in the spiny murex shell. This completes the first stage of the painting. An underpainting such as this, rendered in black, white, and gray, is called a "grisaille." It needs to be thoroughly dry before the next painting session can be-

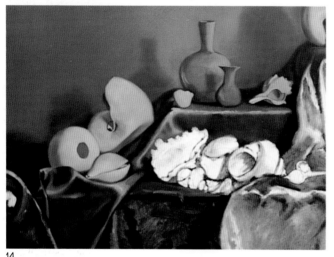

14

15

Before you begin each painting session, scrub in a thin coat of medium over the dry underpainting.

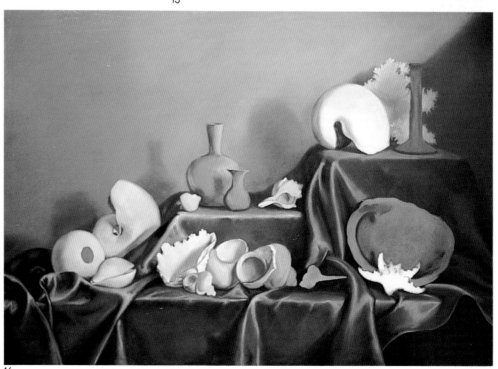

16

gin. Drying time depends on the medium used; a very thin coat of painting medium should be scrubbed over the dry underpainting before starting each new session.

ABALONE SHELL AND STARFISH

17. On the edge of the abalone shell, over a middle-value gray, I take a no. 6 sable and start to indicate the darker shadow areas.

18. Then, taking another clean no. 6 sable, I start laying in the highlights. I keep one brush for my light colors and the other for the dark. I make two different tints of white: One has a touch of alizarin crimson, and the other a touch of Thalo blue or Thalo green.

19. I start to model the form in the rest of the shell. Now for the important value test: If the light areas have been kept in a low enough key, the highlights will create a lively contrast and appear bright.

20. I blend all the colors together and then use a small brush to correct and suggest the various forms, or color shapes, inside the shell.

21. I keep repeating this procedure. I blend, redraw the shapes with dark and light, and constantly refine until I'm pleased with the forms. I draw in the bumps on the starfish with a small sable brush and black paint.

22. I paint in the various colors of the starfish using mixtures of white, yellow ochre, and burnt sienna. I add black and burnt umber to these mixtures for shadow areas.

23. Using small sable brushes to render the intricate form, I work back and forth between the light and shadow areas. I paint the larger shapes of the starfish first, saving the smaller and more subtle ones until last.

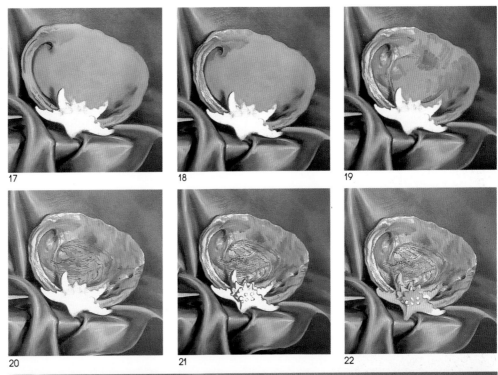

17 18 19

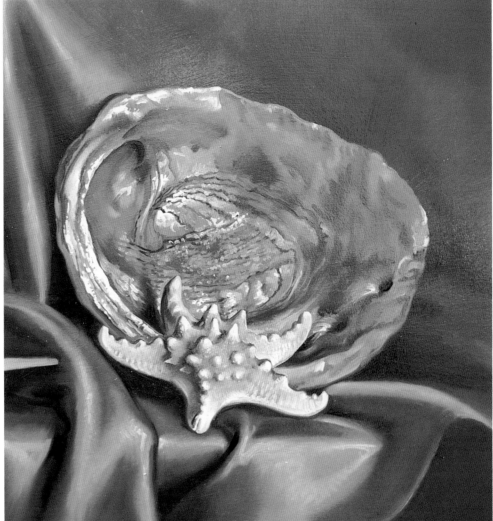

20 21 22

23

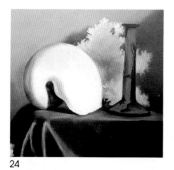

24

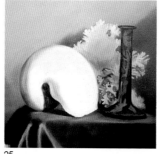

25

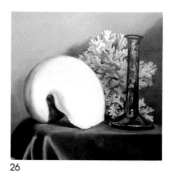

26

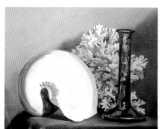

27

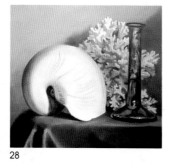

28

29

NAUTILUS SHELL, CORAL, AND COLORED GLASS

24. I carefully lay in the dark shapes in the antique vase, paying attention to where they are sharp and where they become soft and diffused. I fill with light grays the general tone and form of the coral.

25. I look for the subtle color changes of the glass vase, then paint them in carefully. Using my sable brushes I start to indicate the delicate branches of the coral with a darker gray similar to the background tones.

26. I soften and refine the vase, then add opaque highlights. I finish the detailed forms of the coral. Then, to create a sense of space between the coral and the vase, I keep the area behind the vase diffused and out of focus. I do this by carefully blending and stippling.

27. Over the dry underpainting of the nautilus shell, I boldly restate the darks and lights.

28. I blend these tones with a clean, dry blending brush and paint into the wet paint with various grays to define the more subtle shapes. I add a yellowish reflection with a tint of yellow ochre. Note the pinkish gray that defines the right-hand edge of the shell that separates it from the coral.

29. Once again I blend the nautilus shell colors, this time very lightly so as not to lose any detail of modeling. I take a clean sable brush dipped in burnt sienna and very carefully draw in the stripes. I add a touch of black where the sienna stripe meets the shadow area underneath the nautilus. These stripes are easier to paint if you let the shell dry first.

30. At this final stage, I add the highlight using a heavy load of thick white paint. This heavily applied opaque paint is called "impasto." I soften just the edge of the impasto to make the highlight appear as if it rests directly on the surface of the shell.

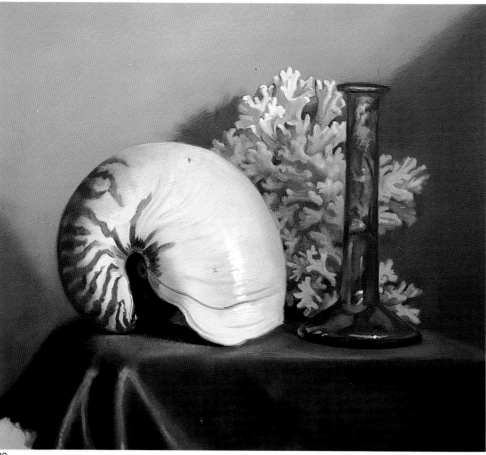

30

If the light areas in a painting are kept in a relatively low value range, highlights will provide contrast and appear bright.

WHELK SHELL AND COLORED GLASS

31. Using small sable brushes, I render the whelk shell on the right with mixtures of gray, burnt sienna, and burnt umber.

32. I soften the sienna pattern with a blending brush and then paint a sharp accent around the opening of the shell. With a sable brush reserved for dark tones, I start to pick out shapes in the left-hand shell.

33. The smaller, left-hand shell is painted in using the same procedure used for the nautilus: by applying various colors, then blending, and adding white impasto highlights last. For the vases, I scrub in tones of color. The lavender is created from mixing alizarin crimson and black.

34. I paint the rest of the color patterns that I observe in the vases and blend them. Using small sables, I redefine the sharp edges on the lips of the vases with both light and dark values (black and yellow ochre).

35. As I refine the larger color shapes in the vases, I search out the more subtle patches of color and paint them in, such as the tiny gold flecks of yellow ochre. Finally, I add the highlights, which consist of tiny bright dots of heavy impasto paint.

31

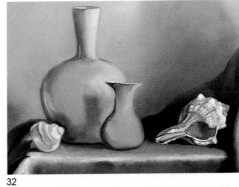

32

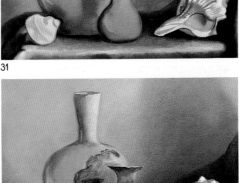

33

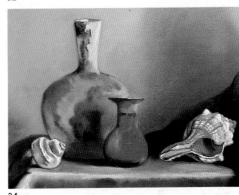

34

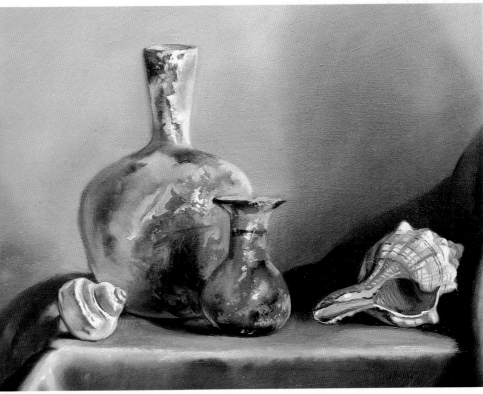

35

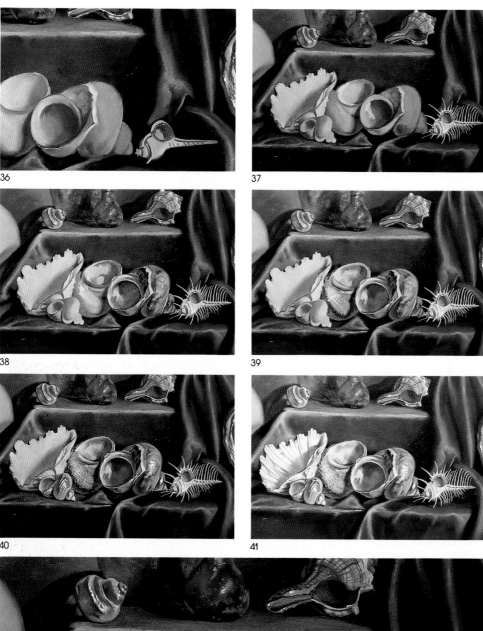

36

37

38

39

40

41

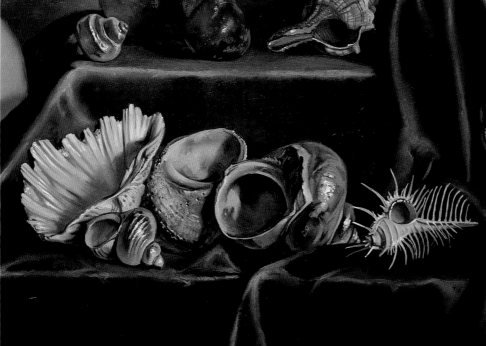

42

SEASHELLS

36. On the spiny murex shell, I take dark gray paint and draw in the inner shapes of the shell.

37. With several values of gray, I completely render the spiny murex before adding the spines. If there is a problem drawing the thin spines, they can be erased with a cloth without losing the background and painted again—an advantage of a dry underpainting!

38. The colors and shadow areas of the two middle shells are painted in strongly over the grisaille underpainting with bristle brushes.

39. As I proceed with the two middle shells, I let their local colors be my guide and lay in the cast shadows. Note the touches of pinks and greens in these shells. Then I let the different brushstrokes overlap one another in the wet paint.

40. I blend the different colors together with a dry brush. With my sables I paint in the details and sharper edges. The small shell to the left is painted similarly to the nautilus. Impasto highlights are added to the small shell and to the shell next to the murex. I begin laying in shades of pink and gray on the shell farthest left.

41. For the shell farthest left, getting the values right was difficult. Although the shell appears pure white, if it were painted white the highlights wouldn't register. To tone down its whiteness, I paint over the lightest area with white combined with a touch of ultramarine blue and thinned with painting medium. Over this slightly blue-tinge I describe the ridges with a gray mixed with blue.

42. The inside of the shell is blended and bright white impasto highlights are applied to the off-white surface.

COWRIE SHELL, NAUTILUS SHELL, AND SEA URCHIN

43. The brown tones of the cowrie shell are painted with a mixture of yellow ochre, white, and burnt umber. The bluish tint is created from mixing just black and white.

44. Into wet paint, I add the spots, shadow areas, and sharp line indicating the two

43

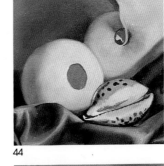
44

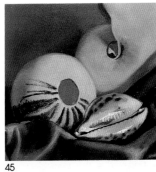
45

46

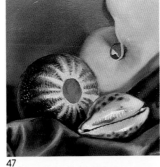
47

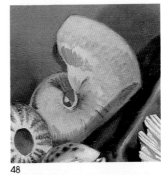
48

49

halves of the cowrie shell with black paint. (The wetness of the paint reduces the intensity of the black.)

45. I blend the colors of the cowrie carefully leaving the sharp black line of the two halves of the shell and add the highlights of white impasto. I mix a purple using alizarin crimson, black, and ultramarine blue and paint in the striped pattern of the sea urchin.

46. When I have filled in the urchin's pattern, I add the yellow ochre and gray reflection. I then blend and soften the colors.

47. To reinforce the striped pattern and bring out the whites, I paint back into the wet surface of the urchin. Then with my light and dark sables, I lay in with small strokes the details of the urchin's ridges and bumps.

48. To the nautilus shell, I lay in a variety of blue, green, and gray tones with bristle brushes and bold strokes.

49. I refine my modeling on the nautilus adding touches of alizarin crimson and Thalo blue and then blend all the tones together.

50. I finish the shell by painting in the ringed indentations and adding impasto highlights.

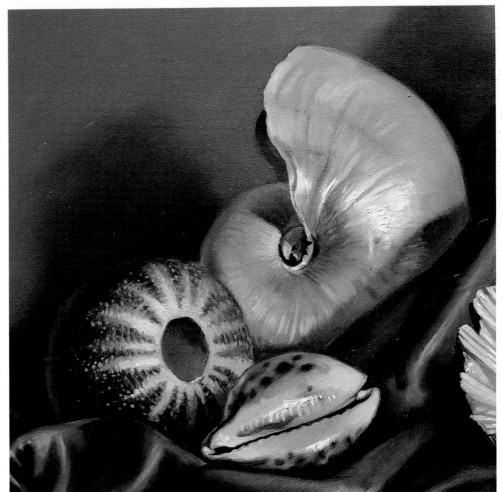
50

51

52

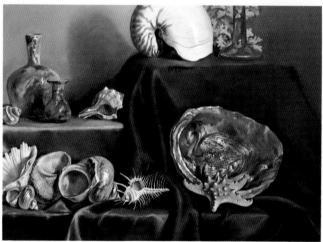

53

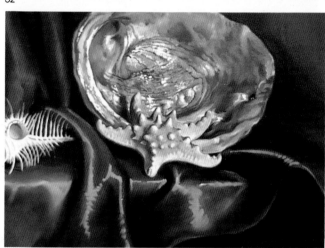

54

A glaze
consisting of
medium and
transparent
color enriches
the painting
surface by
allowing the
underpainting
to show
through.

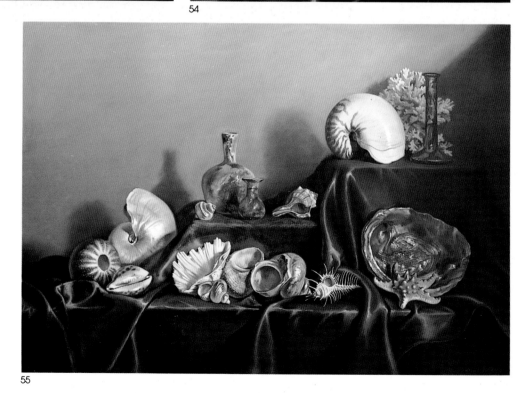

55

SATIN DRAPERY

51. I apply a glaze over the drapery with color using a mixture of burnt umber, alizarin crimson, and lots of medium. A glaze is a transparent coat of paint that enables a dry undercoat to show from underneath, similar to the effect of looking through colored glass.

52. The first application of the glaze goes on with large brushstrokes and is then blended smooth with a large, dry blending brush. The glaze should be thin enough to allow the underpainting to show through. I paint over the spines of the murex shell instead of around them because it would be too difficult to paint the glaze around the delicate spines.

53. While the glaze is still wet, I restate the dark accents with black. Note these areas occur most often where the drapery falls or folds.

54. Opaque highlights are added by mixing white with alizarin crimson and burnt umber, using *no* medium. (Medium lessens opacity and the effectiveness of highlight areas requires a high degree of opacity.)

55. The opaque highlights are blended in. The rest of the drapery is painted in the same fashion. The spines of the murex shell are repainted.

PEACOCK FEATHERS

56. As an afterthought, I decide to add some peacock feathers. I first paint their cast shadows on the background and blend them, keeping the edges very soft. I outline the feathers and paint in their brightly colored eyes.

57. The feather on the left shows its basic shape painted with a mixture of yellow ochre and burnt umber. I then take my sable brush and paint the various colored highlights into the wet paint, as seen on the right feather.

58. A third feather is added to balance the composition, and the painting is finished.

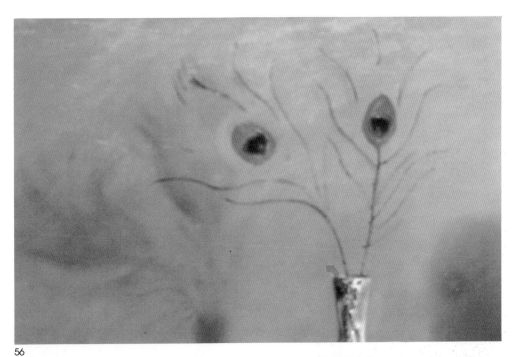

56

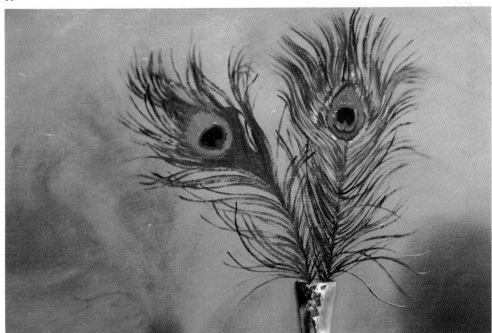

57

58

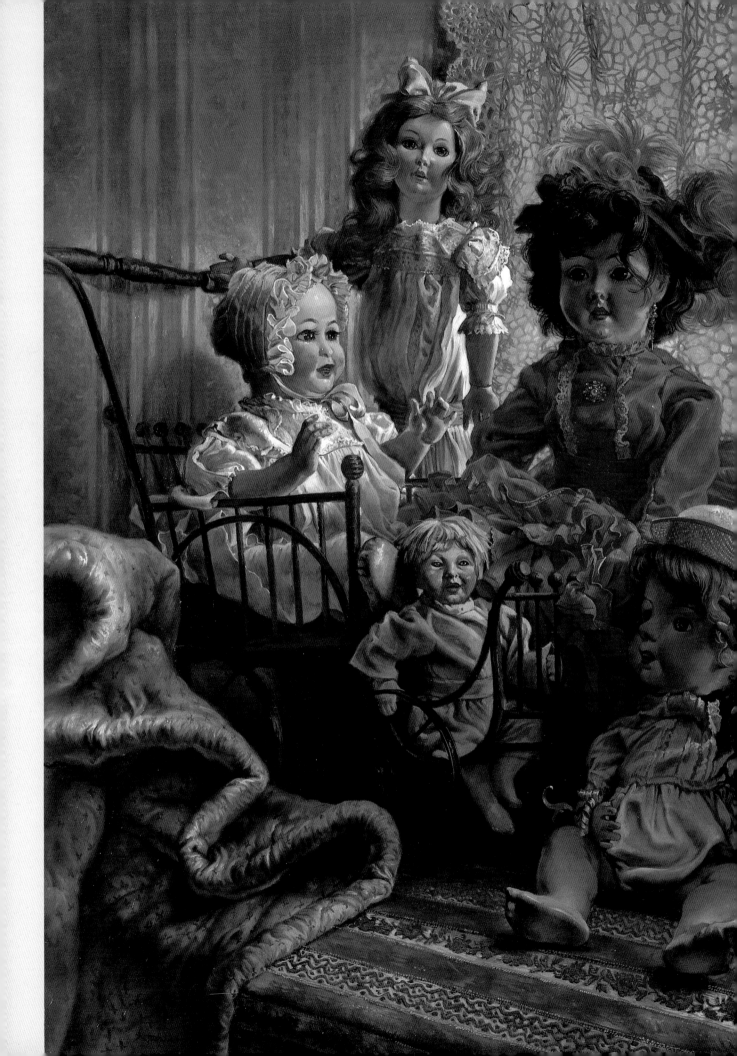

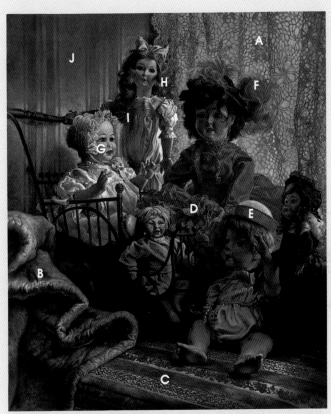

ANTIQUE DOLLS, oil on panel, 30" × 36" (76.20 × 91.44 cm).

TEXTURES

A. *Lace*

B. *Satin*

C. *Velvet brocade*

D. *Chiffon*

E. *Woven straw*

F. *Feathers*

G. *Porcelain*

H. *Synthetic hair*

I. *Cloth dress and bonnet*

J. *Wallpaper*

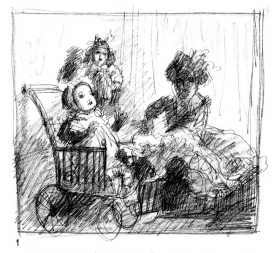

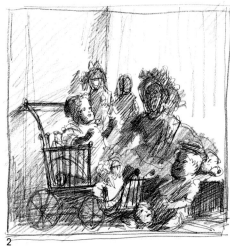

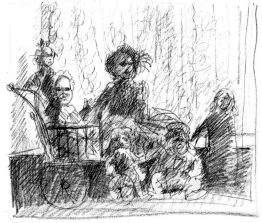

COMPOSITION SKETCHES

1. Using red chalk accented with black ink, I rough in the composition. My interest at this time is not in various details but in chiaroscuro, the contrast between light and dark.

2. I add two more dolls and a doll's head. In this composition, the dolls are smaller and more of the interior is seen. Although the effect of backlighting pleases me, the doll's head in the foreground adds an unwanted grotesque feeling.

3. This arrangement is more horizontal and adds a lace design to the curtains. The small doll from the previous sketch's background has been moved to the foreground to give a dark supportive column on the right side. However, the way the dolls all face the front doesn't work for me.

4. I sketch in the folds of the curtains to help indicate the light direction. I also vary the positions of the dolls so that I get a more interesting interplay between the characters that seems to make them more animated.

5. A quilt in the left corner forms a curved line that helps to bring the eye back into the composition.

6. After several attempts to compose the picture horizontally, I change my mind and decide that it works best vertically.

THE UNDERPAINTING

7. Using a small sable, I draw in a suitable sketch with burnt umber and some medium on the gessoed Masonite panel.

8. The shadows are suggested with burnt umber applied with a round bristle brush.

9. I lay in the large areas with local color and also indicate the shadows. I apply paint quite thinly, using pressure on the brush.

10. Each large area is blended with a dry blending brush to eliminate brushstroke marks.

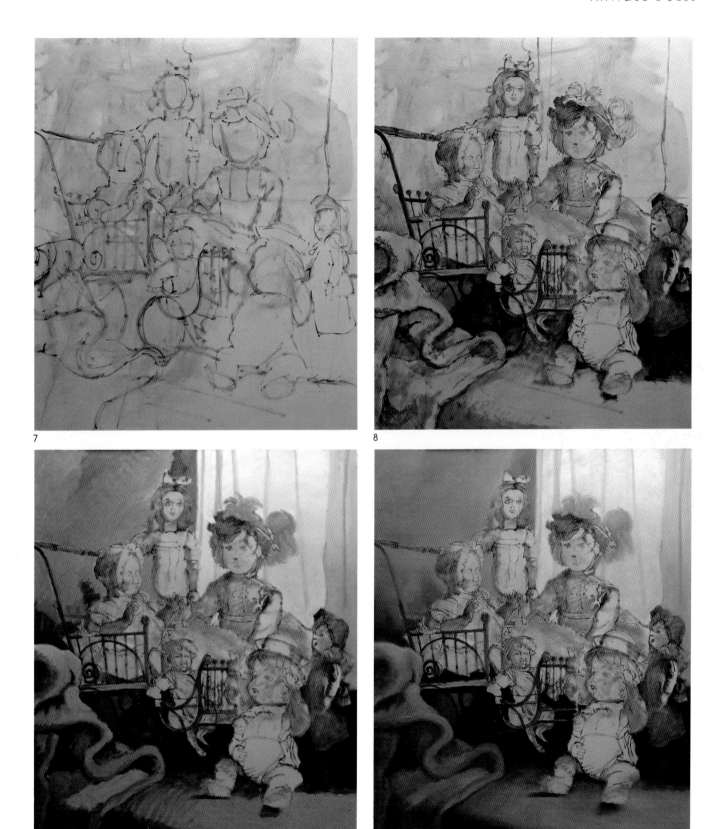

7

8

9

10

The luminous surface of certain textures, such as
satin or porcelain, can be achieved by softly
blending colors and values with a dry bristle brush.

LACE CURTAIN

11. I start to fill in the intricate pattern of the lace curtain with a small sable loaded with a mixture of yellow ochre and black.

12. The larger areas of the curtain are painted in first. Then the lines indicating the folds of the cloth are drawn in. Applied to these folds are little dots of light which help to suggest the effect of light coming through two thicknesses of cloth. These dots of light are painted with a thick white mixed with Naples yellow.

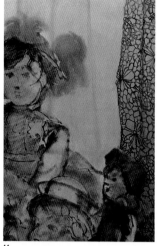
11

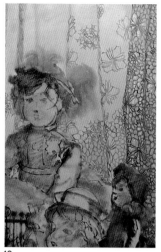
12

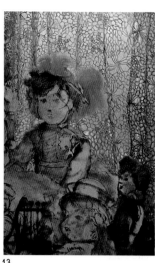
13

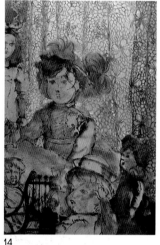
14

13. I draw in the rest of the lace pattern and, to bring the largest doll's head forward, I place dots of light behind it.

14. The area of curtain behind the large doll is blended with a dry blending brush; this out-of-focus effect creates a sense of depth. Darks are painted into the cloud of mauve-colored feathers with a mixture of dark gray and alizarin crimson.

15. The curtain is refined and its scalloped edge painted with a light-value gray that makes it stand away from the cast shadow on the background wall. The feathers are painted wet into wet, so that they blend softly with the lace-patterned background.

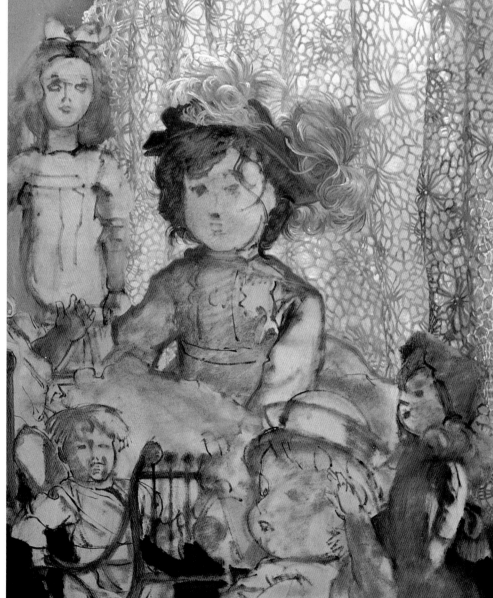
15

SYNTHETIC HAIR
AND SATIN RIBBON

16. I paint a flat, even tone of burnt sienna for the standing doll's hair. Then, with a small sable loaded with black paint, I start to paint in the shadow tones. The satin ribbon is composed of two colors: pink for the light areas and dark gray for the shadow areas.

17. The hair is further modeled with the base coat of burnt sienna and black shadows and then blended with a blending brush. The ribbon is also blended, and I make sure to keep the line between light and shadow very soft and graduated. The cast shadow on the wall from the curtain is laid in with dark brown. Note that the part closer to the curtain is kept distinct and in focus and the part farthest away is more diffused.

18. The highlights on the sienna hair are painted in carefully with Naples yellow and follow the direction of the flow of hair. The edges of the yellow highlights are blended into the burnt sienna to follow the basic forms of the hair. Opaque white highlights are added to the pink bow.

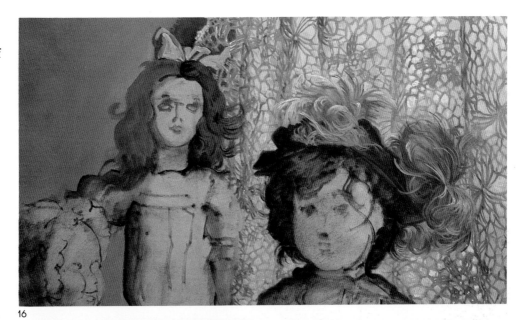

16

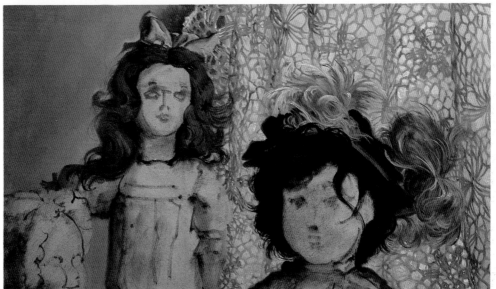

17

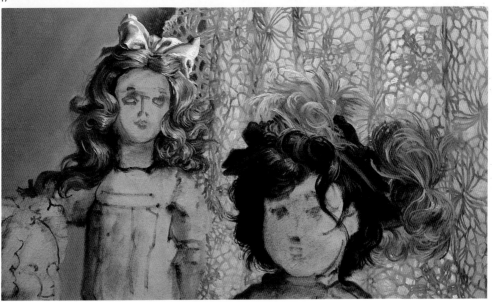

18

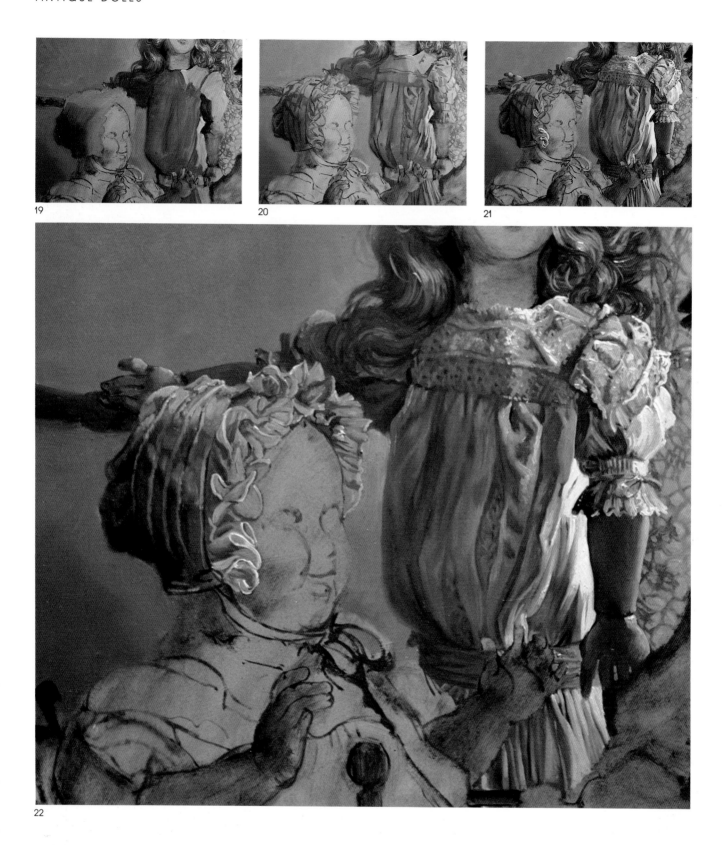

19

20

21

22

You can achieve a soft edge between
objects by painting wet into wet.

CLOTH DRESS AND BONNET

19. I paint the standing doll's dress in two tones: a middle-value light and a middle-value dark. The baby doll's bonnet is also composed of two tones of the same color; then as a second step the tones are blended together.

20. After the tones are blended and the paint is still wet, I draw in dark gray paint to explain the ruffles of the bonnet and doll's dress.

21. I soften the dark gray lines; and then using a clean sable brush loaded with white, I lay in opaque highlights on the light-toned areas.

22. Working back and forth between accents of dark gray and tinted white highlights, I finish the dress and bonnet.

CLOTH DOLL CLOTHES

23. I paint in the baby doll's dress and boy doll's clothes with a darker shade of gray than I used on the bonnet and standing doll's dress because these dolls are farther away from the light source and thus more in shadow.

24. The baby doll's dress is rendered following the same painting procedure as the bonnet and the standing doll's dress. I paint the antique stroller in a flat, even tone of burnt umber while the dress is still wet, so that I keep a soft edge where the edges of the doll and stroller meet.

25. Yellow ochre highlights are added on the post of the stroller. Dark-colored shadows are painted into the gray tone of the boy doll's clothes.

26. Highlights are added but kept subdued and low in value because the boy doll is partly in shadow.

27. The foreground doll's clothes are painted in following the same procedure as used for the bonnet and other doll dresses: by laying in various shades of gray. I keep the lights subdued by adding ultramarine blue to the lighter tones to suggest a shaded area.

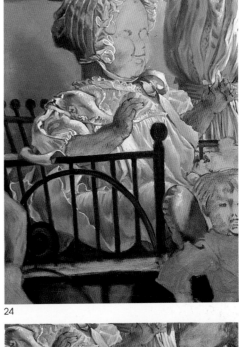

23

24

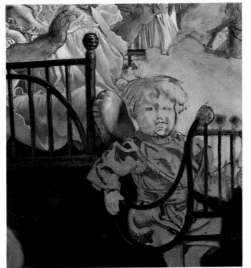

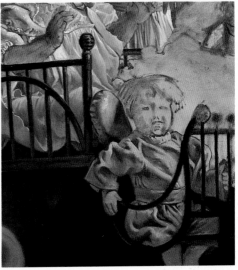

25

26

27

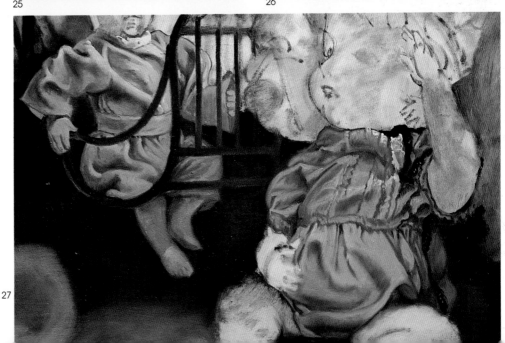

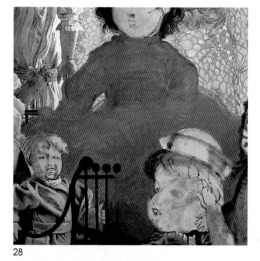

28

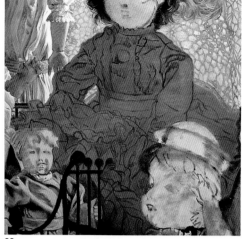

29

30

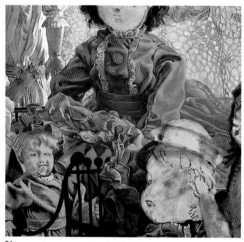

31

CHIFFON

28. I paint in a basic tone of vermilion and burnt umber for the pink dress. I overlap the lace curtain with thin paint to further suggest its airy transparency.

29. Using a sable brush filled with burnt umber, I draw in the complicated ruffles and folds of the pink dress.

30. With a mixture of alizarin crimson and white, I carefully paint in the highlights. Touches of pure vermilion are added in the shadow areas of the ruffles to suggest light coming through the translucent material of the dress.

31. Warm gray is added to areas half in light and half in shadow in the sleeve and bodice. Reflected light is indicated with vermilion.

32. Each section of the pink dress is blended and redefined with fresh paint. Because blending lessens color intensity, accent areas and highlights must be restated after an area has been blended. The jeweled brooch is painted in. Its center pearl is composed of a light gray, a Naples yellow reflection, and a pure white highlight. All stones have a pure white highlight to show that they are polished and shiny.

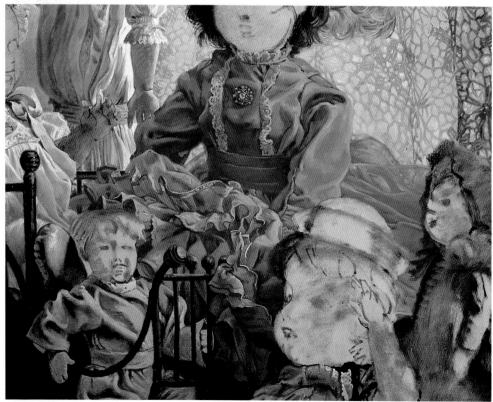

32

PORCELAIN

33. I lay in a gray tinted with yellow ochre for the light areas of the baby doll's porcelain face. The cheeks are tinted with vermilion and the shadow area is pure gray.

34. Darks are drawn in the shadow areas around the eyes, nose, mouth, and chin. A lighter mixture of yellow ochre and white is modeled into the center of the light areas. The red lips are filled in with a mixture of vermilion and alizarin crimson toned down with burnt umber and white.

35. Once the head is finished and dry, I cover it with a thin coat of medium and then paint in the details of eyes, eyebrows, and mouth. The eyes are composed of burnt sienna and burnt umber with pure black centers. To suggest the hard surface of the porcelain, I add strong highlights to the centers of the light areas.

36. The arms of the baby doll are finished, and I paint in the boy doll's face using the same sequence of application as I did on the baby doll's head.

37. Because these heads are mostly in shadow, I begin with a dark gray tone and draw in the features with an even darker gray. Yellow ochre mixed with black is laid down for the basic color of the doll's hair.

38. Tints of flesh tone are painted into the dark gray and then blended. Over a base of blended grays and flesh tones, I paint in the details of the features. Highlights of Naples yellow are added to the hair.

33

34

35

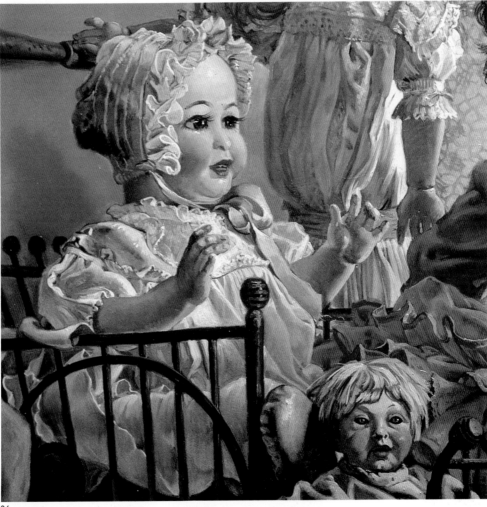

36

37

38

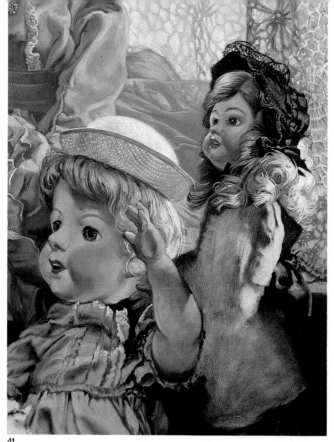

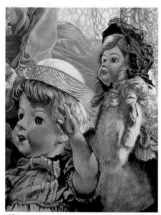

39

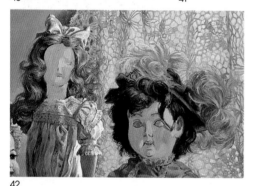

40 **41**

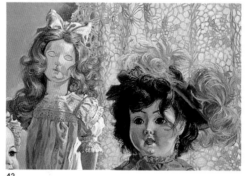

42 **43**

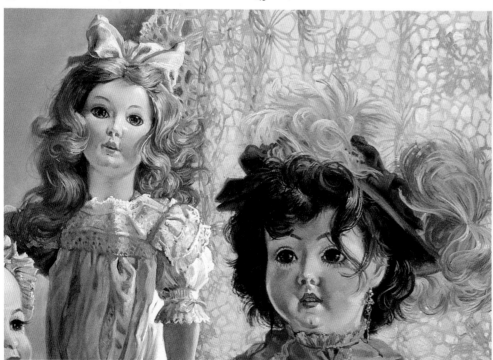

44

WOVEN STRAW AND CLOTH BONNET

39. I paint in the black bonnet using mixtures of black and white. Basic tones of light and shadow are painted in for the foreground doll's straw hat.
40. Using my sables, I draw in the general pattern of the weave of the straw hat.
41. I carefully finish the hat with both regular and irregular linear patterns, and then indicate the points of light showing through the hat's rim. Using small sables, I suggest the weave on the crown of the hat with a mixture of black and yellow ochre; the highlights are made of white and Naples yellow.
42. I block in the shadow areas on the two faces with gray. The lighter flesh areas are mixed with white, yellow ochre, and vermilion. I then start to indicate detail on the large doll's face.
43. The large doll's face is rendered in the same manner as the baby doll's (see steps 35–38). I start to define the features of the standing doll.
44. The heads are softened and then reaccented. Note that any time that an area is blended, the colors necessarily become softer and more muted. Therefore, these areas must be redefined with dark accents and light highlights. A cast shadow from a strand of hair is painted on the face of the standing doll.

VELVET BROCADE

45. The foreground doll's legs and feet are painted in the same manner as the dolls' faces but the color is more grayed. With strong strokes I paint the velvet brocade.
46. Applied to wet paint, the hard edges of the stripes are softly blended with a dry blending brush, and I draw in the various designs with small sable brushes.
47. With small opaque dots of light, I indicate the edge and thickness of the stripes. On

45

46

47

48

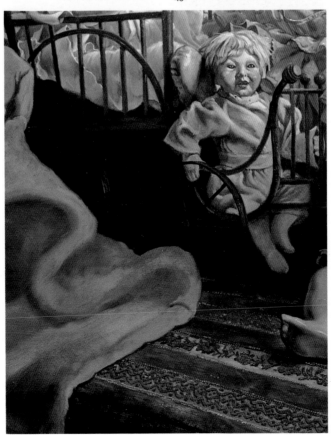

49

the rose and leaf pattern, I also carefully paint in cast shadows with small dots of dark paint and highlights with dots of white.

48. I add lighter random brushstrokes to the green stripes; these areas of light suggest the sheen seen on worn velvets and brocades. To soften the patterned stripes, I don't blend it because it would only smear the complicated designs. Instead, I use the same brush as I would to blend—a flat bristle brush—and turn it perpendicular to the canvas, using a jabbing motion that I refer to as stippling. This technique is useful for flattening and spreading the paint slightly without smearing it.

49. After applying a thin glaze to the wooden wheels of the stroller, I paint them in with small sables and dark paint.

Stippling is an effective technique for rendering textures that need to be softened very slightly, not blended.

50

51

52

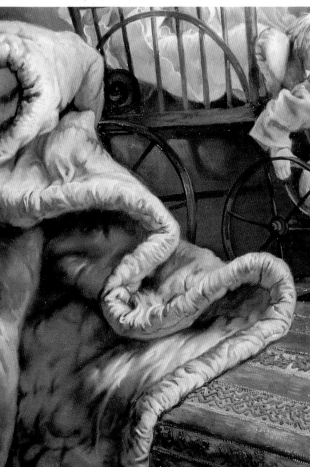

53

54

SATIN QUILT

50. Over the dry middle tone of the satin quilt, I put a clear coat of thin medium. Into this, I brush in dark accents and highlights to explain the various curving forms.

51. I blend these tones together with a dry blending brush.

52. I reinstate the dark accents and highlights. This time I only soften the edges of the brushstrokes.

53. The rest of the quilt is rendered using the same procedure of blending the edges of the dark and light brushstrokes.

54. The dark blue doll's dress on the left is rendered by first, laying in an almost black tone tinted with blue; then, I paint back into this blue-black color with lighter blue touches. A thin glaze of alizarin crimson is applied over the shadow areas on the pink dress to make it more vibrant and a richer color.

WALLPAPER

55. I brush in the shadows on the wall boldly, using medium to dilute the color, a green mixture of yellow, blue, and black.

56. Here, I have blended the shadows into the background wall. Then, using a large bristle brush, I draw in the green stripes with a mixture of yellow, blue, and black.

57. I use a blending brush over the stripes to make them lose their sharpness.

58. Soft pink tones are brushed in over the blended green stripes. The surface of the wall is then stippled until the desired mingling of colors is achieved.

SATIN QUILT

59. With a lot of medium and a little Naples yellow, I apply a glaze to the quilt. To sharpen the shadow areas, I add a dark gray to the glaze.

60. I smooth out the entire surface of the quilt with a blending brush and apply a brown tone to certain areas to describe the cast shadows.

61. I paint back highlights in specific areas such as the baby doll's bonnet, the standing doll's hair, the light area behind the large doll. As I do this, I carefully consider the rhythm of the whole painting, keeping in mind the way highlights create focal points for the viewer's eye.

55

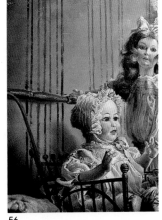

56

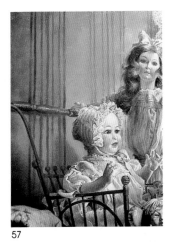

57

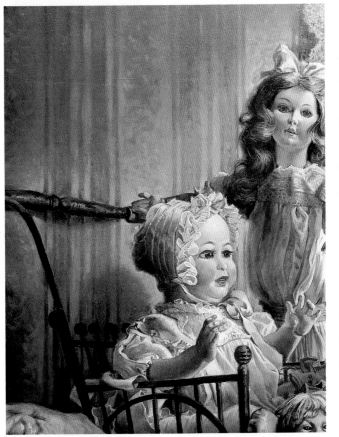

58

A texture is slowly developed by first stating the various tones of color, then blending the colors to create form, and finally by restating dark accent and highlight areas.

59

60

61

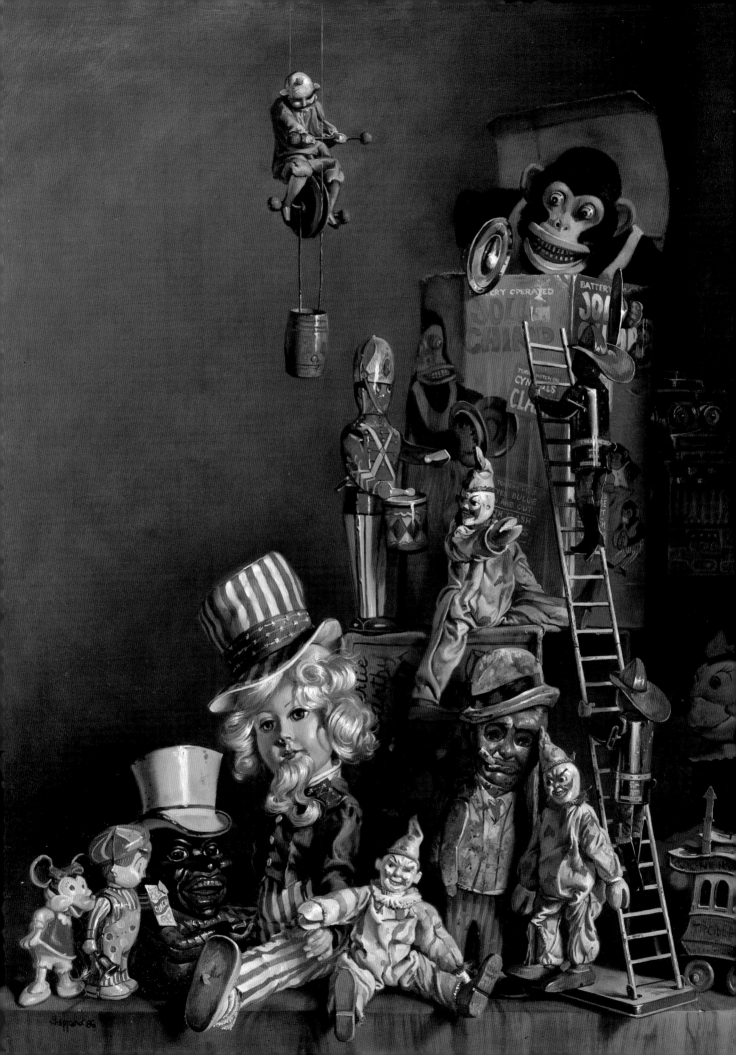

MYHRE'S TOYS

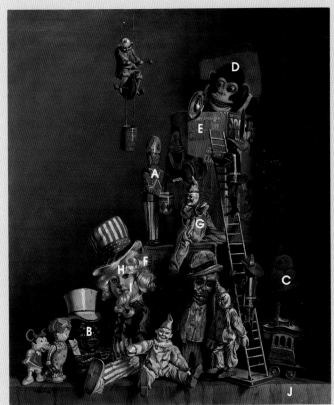

MYHRE'S TOYS, oil on panel, 30" × 36" (76.20 × 91.44 cm).

TEXTURES

A. *Painted tin*

B. *Painted cast iron*

C. *Rubber*

D. *Synthetic fur*

E. *Cardboard*

F. *Synthetic hair*

G. *Cotton cloth*

H. *Glass eye*

I. *Porcelain*

J. *Wood grain*

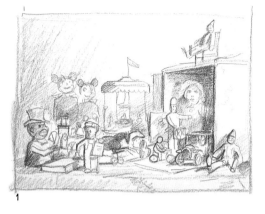

1

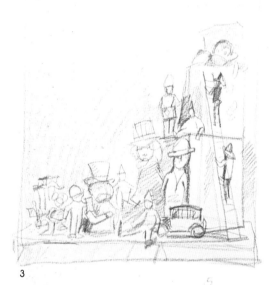

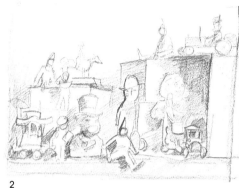

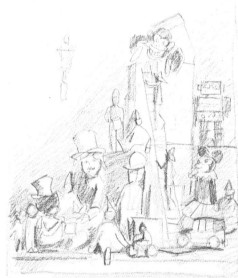

3

4

5

COMPOSITION SKETCHES

1. To suggest a composition, I place a number of toys on a table. Then I put a few toys in an open box to create an interesting shadow area.

2. More boxes are added to provide more levels. I begin to group the toys and arrange pleasing juxtapositions, but the overall composition is still not interesting to me.

3. Suggested drapery on the base proves too busy, so I make the composition follow a diagonal across the picture and place the monkey at the top.

4. Here, the vertical column of toys is slightly off center. The toys on the right are placed in the shadow area.

5. I work with the shadow area until it seems right. I constantly change each toy until it relates well with the ones surrounding it. Each object's shape, size, and type are important to the overall composition.

THE UNDERPAINTING

6. With small sables, I draw in the contours of the toys with burnt umber on a sepia-toned Masonite board.

7. Using more burnt umber I suggest the shadow areas as well as those toys that I intend to keep dark.

8. With bold strokes, I use a round bristle brush to lay in the background using combinations of white, yellow ochre, burnt umber, and black.

9. After the background is completely covered, I use a blending brush to blend the tones together and to get rid of visible brushstrokes.

6

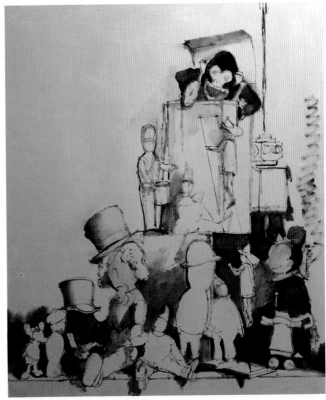

7

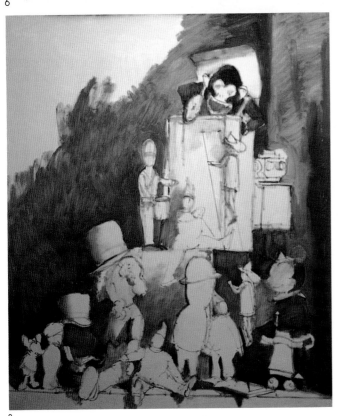

8

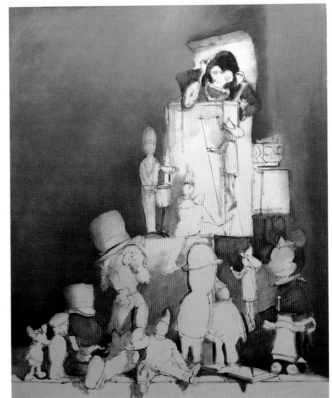

9

10

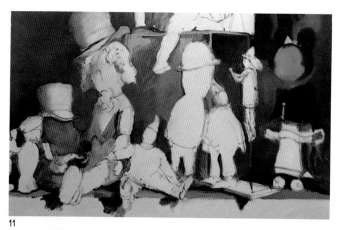

11

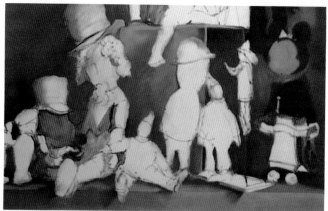

12

As the cast shadow recedes from the object, the tone grows paler, softer, and more diffused.

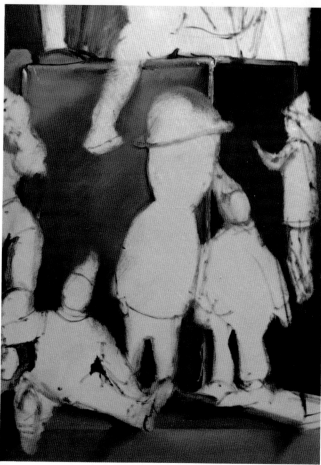

13

10. Beginning with the toys that are in shadow, I paint in the large shapes with grays, burnt umber, and black. I do this to make sure that this area is kept low in value and subsequent values will be gauged against this area. Otherwise, if the values in this area were too light, the rest of the picture's values would also be too light. These tones are then blended and softened against the background.

11. I paint in the tabletop with flat tones using a bristle brush. Cast shadows are painted in with burnt umber combined with a mixture of white and yellow ochre.

12. I paint in the front of the table with a mixture of burnt umber and yellow ochre, keeping the side closest to the light source lighter and the far side darker. The cast shadows are made sharper where they originate and more diffused at their extremities. The cardboard box is laid in with flat tones of burnt umber and burnt umber and white.

13. To describe the thickness and roundness of the box, I accent its edges with darks and highlights.

FUR AND TIN

14. I rough in the basic colors and shadow areas of the monkey's box.

15. The colors are blended and redefined to indicate the planes of the box.

16. For the monkey's deep black fur, a thin coat of black is applied over a layer of dry burnt umber. I lay in middle-value greens and pinks for the cymbals, face, and ears.

17. I blend the black fur into the background shapes. With dark gray tones, I paint in shapes on the cymbals and indicate shadow areas on the face.

18. Gray highlights are added to the monkey's fur. These

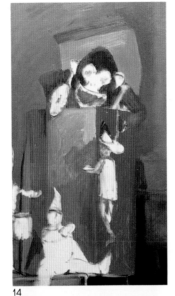 14
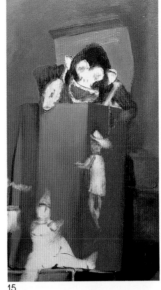 15

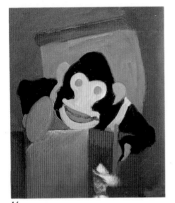 16
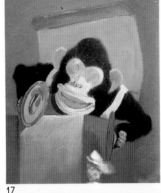 17
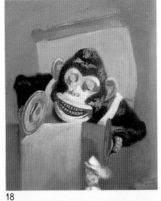 18
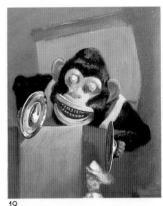 19

highlights are soft and diffused because of the low reflectivity of fur, especially dark fur. I paint in darker shadows on the face and around the teeth with a mixture of burnt umber and alizarin crimson. Color is added to the cymbal to reflect the red of the monkey's box.

19. I paint in highlights on the face using the original middle-value pink with some white added. Heavy impasto white highlights are applied to the cymbals.

20. I draw in the details of the eyes and cymbals. The highlights on the cymbals are sharp because of the high reflectivity of metal. The edge of the box also catches a bright highlight because of its slick surface.

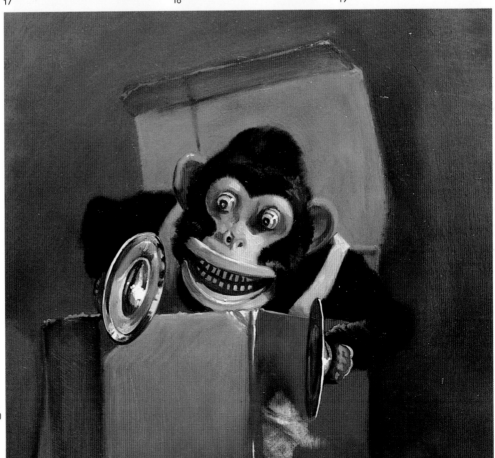 20

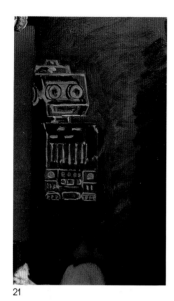

21

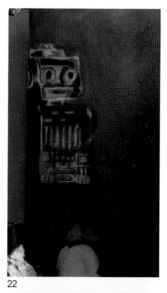

22

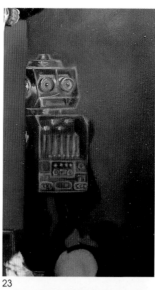

23

TIN ROBOT

21. After applying a coat of medium over the robot, I render the details. These details are then blended so that they remain low key and won't jump out of the shadow. Shadow areas are scrubbed in around the robot; they are composed of gray mixed with burnt umber.

22. I blend the robot into the shadowed background with a dry blending brush.

23. To keep the robot securely in shadow, I retouch certain areas of the robot to explain his form but purposely leave other areas soft and diffused.

RUBBER AND PAINTED TIN

24. Minnie Mouse's colors are painted in subdued tones and each edge is kept soft to keep her in the background.

25. The details of Minnie's face and the polka dots of her dress are kept in the same subdued tones as the robot.

26. The various shapes that make up the trolley car are laid in with its local colors.

27. The details of shadow and light are placed on the trolley car. The highlights on the side of the chimney show the thickness of the metal. The opaque paint and light gray to suggest dust on the trolley's roof make a strong contrast with Minnie and place the trolley in the foreground.

Objects in shadow are kept subdued and in the background plane with soft, hazy edges.

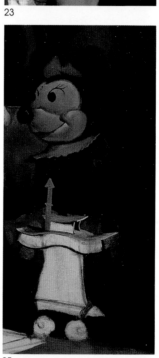

24

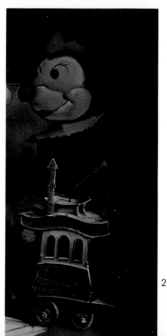

25

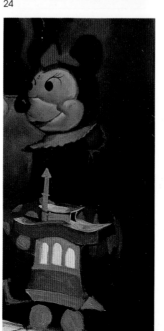

26

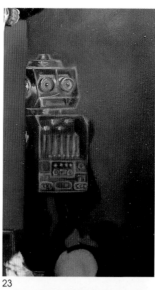

27

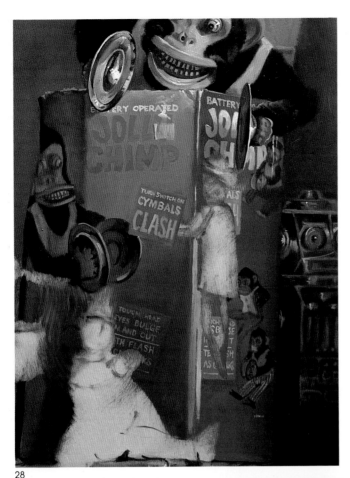

28

29

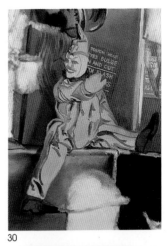

30

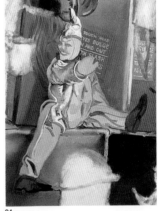

31

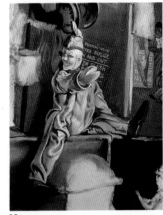

32

CARDBOARD AND CLOTH CLOWN

28. Over the dry underpainting of the monkey's box, I apply a thin coat of medium. I then carefully draw in the type and pictures. To make the monkey's image on the left side of the box recede, I blend it into the side of the box.

29. I paint in the large flat areas of the clown using a middle tone for each color.

30. Into each middle tone, I lay in the shadows and details with gray or black using a small sable brush.

31. Opaque lines and patches of paint are placed in areas where the cloth catches light.

32. I blend the lights and shadows noting where they appear soft and where they are sharp.

33. The details of the face and buttons are painted in and opaque white highlights are added to the head.

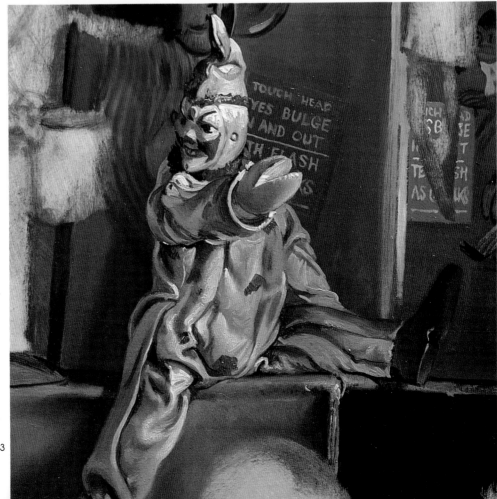

33

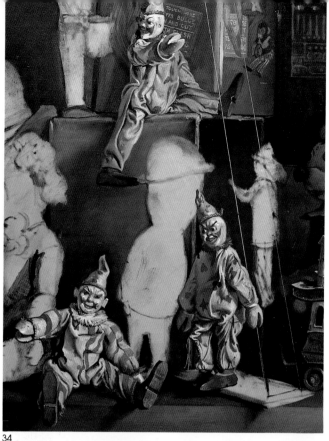

34

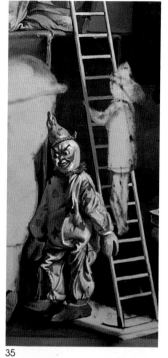

35

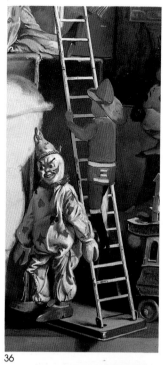

36

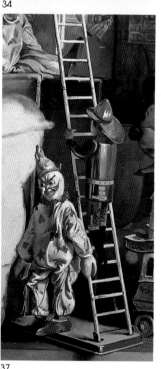

37

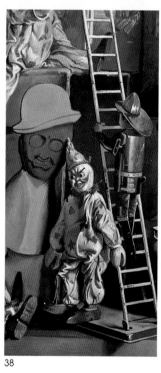

38

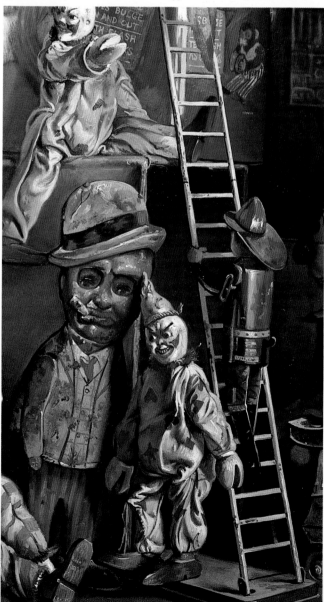

39

A material or texture is characterized by its highlight: The smoother and harder an object, the sharper and brighter the highlight.

CLOTH CLOWN AND PAINTED TIN

34. Using the same procedure as for the first clown, I paint in the other two clowns. For the tin ladder, I take a ruler and a small nail and scratch in the lines.

35. The ladder is drawn in with two tones: a yellow mixed from chrome yellow and yellow ochre for the light areas; and a black for the shadow areas.

36. I paint in the underside of the ladder with black to suggest the rounded form of the rungs. The flat tones of the fireman are laid in.

37. The details of the jacket, pants, and hat are drawn in with small sables; white highlights are added to the jacket's back and sleeve. Note that the highlight on the tin fireman is heavy and sharp compared to the light on the clown's costume, which is more blended and soft.

38. I lay in the middle-value colors on the tin Andy doll. After the colors are blended, I paint a dark line around the shadow side to describe the degree of sharpness and thickness of the metal.

39. The Andy doll is completed in the same manner as the fireman. The sharp highlights help to suggest the shiny, hard surface of the tin.

PAINTED TIN

40. On the tin drummer, I paint in all of the white areas first with light and dark gray.

41. I lay in the color areas and indicate both light and shadow on each color shape.

42. The details of the tin drummer are drawn in over wet paint, although it is easier to draw in details if the colors underneath are dry. Note the sharpness of the drummer compared to the monkey image on the box.

43. Opaque paint is applied to the tin drummer to create the key, pant seams, and gray dust. The white, sharp highlight suggests the hard surface of metal.

40

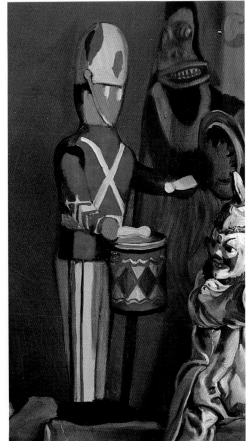

41

42

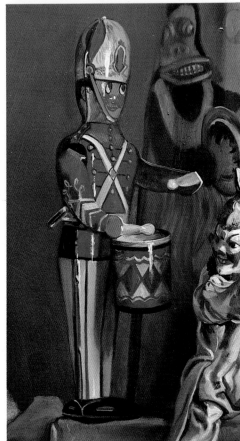

43

44

45

46

SYNTHETIC HAIR AND PORCELAIN

44. The Uncle Sam doll is painted in various shades of grays to indicate light and shadow.

45. A light ochre gray is used as a middle tone for platinum hair. The shadows of the jacket are indicated with black. The light areas of the face are laid in with a light gray mixed with a flesh color.

46. To explain the features of the face and the hair, I draw with dark gray paint using a small sable brush.

47. The hair and face areas are blended with a dry blending brush.

47

48

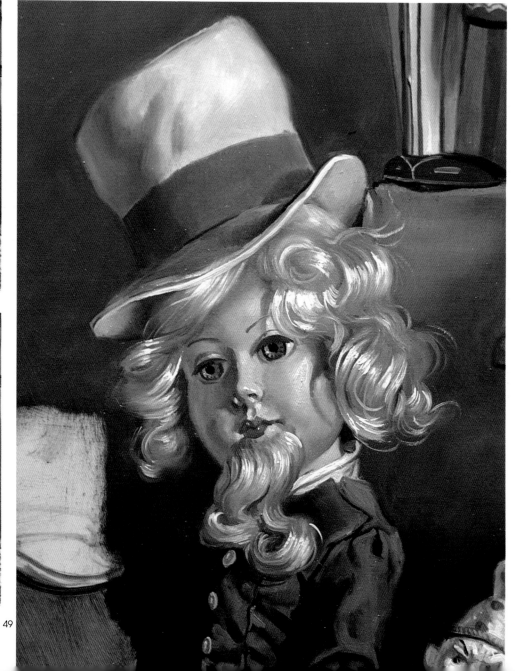

49

48. The details of the doll's face are painted in. Highlights composed of a mixture of white and a tint of Naples yellow are carefully drawn to follow the direction of each curl. Then, with a blending brush and following the basic form of the hair, I pull the ends of each brushstroke in the same direction. Light gray highlights are added to the jacket and blended in.

49. I finish all areas of the doll's hair, making sure that its edges blend softly into the background. At this stage, the hat and jacket are still a grisaille. Later, when they are dry, they will be glazed with color.

PAINTED CAST IRON

50. I fill in the red color of the cast iron bank.

51. A thin layer of black and medium is laid over the burnt umber underpainting of the bank's face. Mixing the black with medium allows the underpainting tones to show through; this creates a rich black like a polished ebony rather than a flat black. Light and shadow areas are applied to the hat.

52. I blend the various tones of the hat, then paint in details with light and dark on the hat, face, and jacket.

53. The face is rendered and bright highlights are applied. Cast iron, like tin, has strong highlights, but there are no sharp edges to the highlight on cast iron. Note that the transparent, shiny black of the face is contrasted against the matte black tone of the background.

50

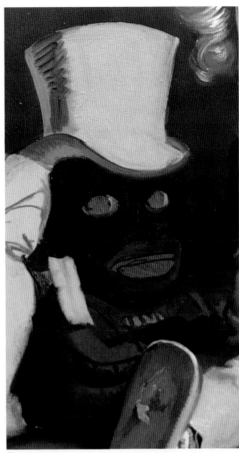

51

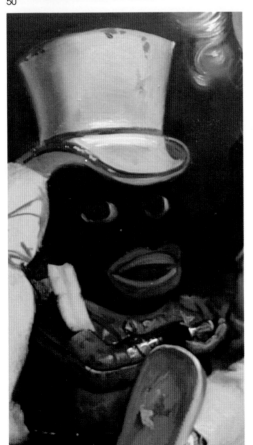

52

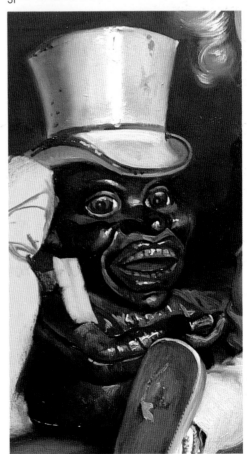

53

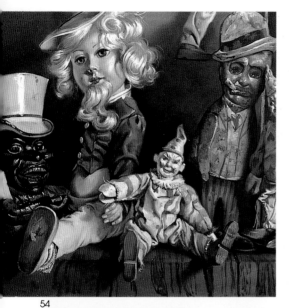

54

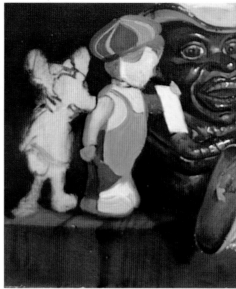

55

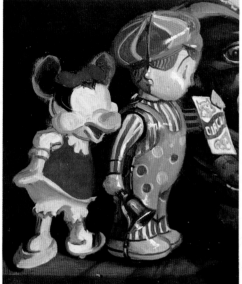

56

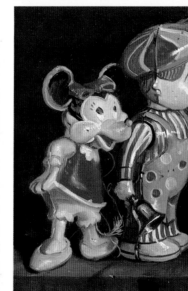

57

58

WOOD GRAIN AND PAINTED TIN

54. Over the dry base of the table, I apply a coat of medium. I draw in lines to suggest the grain of the wood.
55. Using a blending brush, I soften the pattern of the wood by moving the brush in the same direction as the grain. I begin the little tin boy by laying in areas of flat color that are the actual colors of the toy.

PAINTED TIN AND RUBBER

56. The tin boy and a smaller Minnie Mouse are painted in over flat areas of wet paint.
57. To achieve the rubbery texture of Minnie, I applied highlights more sparingly and made them more diffused. This softness suggests a surface that absorbs light rather than reflects it, such as tin or plastic.

CARDBOARD BOX

58. For easier access, I turn the painting on its side to do the lettering on the box. As before, I lay in a coat of medium before I begin to draw in the letters.

CLOTH DOLL CLOTHES

59. Over the dry surface of Uncle Sam, a coat of medium is painted. Into this wet surface, I paint the red stripes basically using tones of red: an intense deep red for light areas and a more muted, middle-value red for shadow areas.

60. With lots of medium and some ultramarine blue, I glaze over the dry grisaille jacket and hat band.

61. I blend the glaze to get rid of the brushstrokes. The underpainting shows through, but I need to reinforce the highlights with touches of opaque light blue. The details of stitching and buttons are then added with small sables and shades of gray paint.

PAINTED TIN AND CLOTH CLOWN

62. I lay in a thin coat of medium over the background where I intend to paint the acrobat clown. I begin with an outline drawing of burnt umber. The barrel is first laid in with a middle tone of yellow ochre, followed by various mixtures of yellow ochre and burnt umber for the shadows and reflections. Then, details are drawn in with small sables and opaque paint to suggest the most light-reflective areas on the barrel's surface.

63. The clown itself is created following the same procedure as for the other three clowns in cloth costumes. For the string, I scratch in the lines with a ruler and a small nail.

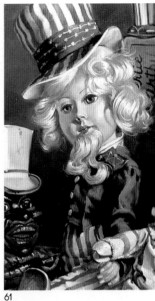

59

60

61

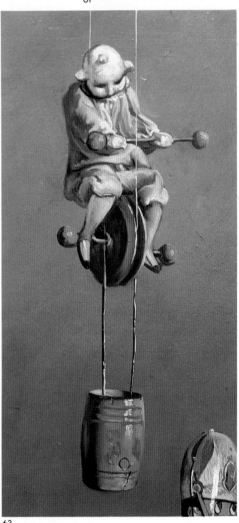

62

63

Cloth has soft forms and no obvious highlights; metal has strong, sharp highlights; and rubber has bright but soft-edged highlights.

SPRING FLOWERS

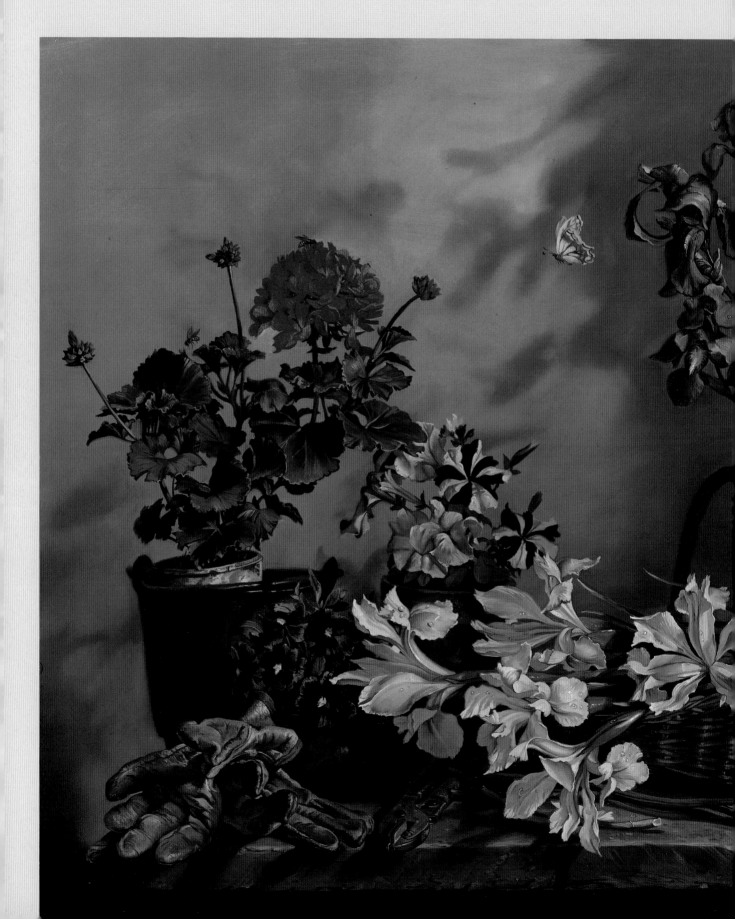

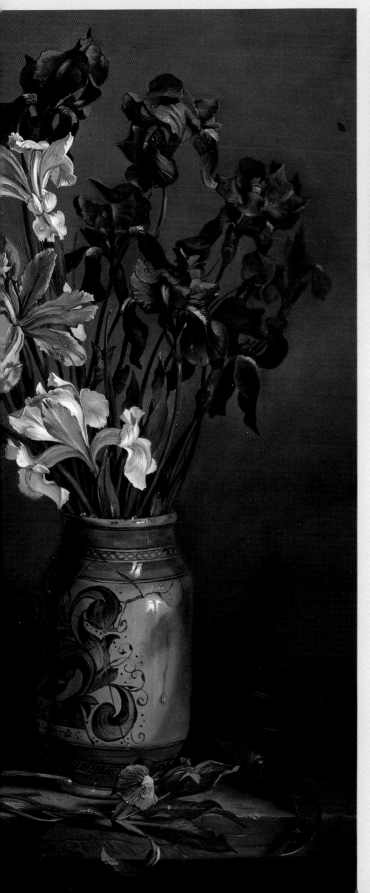

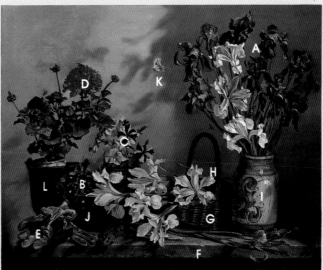

SPRING FLOWERS, oil on panel, 39″ × 31½″ (99.06 × 80.01 cm).

TEXTURES

A. *Irises*

B. *Pansies*

C. *Petunias*

D. *Geraniums*

E. *Old leather gloves*

F. *Weathered wood*

G. *Straw basket*

H. *Water drops*

I. *Ceramic vase*

J. *Copper pot*

K. *Butterfly*

L. *Cast iron pot*

COMPOSITION SKETCHES

1. I plan a composition with three bouquets of flowers, a vase, and a basket.

2. I decide I don't like the flowers and vase in the background, so I move them forward to the foreground. Because cut flowers are prone to wilting, they must be painted immediately. I leave the left side of the picture blank to be composed later. The remaining compositional drawings for other sections of the painting will follow in their natural order.

IRISES

3. Because flowers change so rapidly, I do this painting without benefit of a sketch. The composition grew as the various types of flowers arrived. On a gessoed Masonite board, I lay in flat areas of color composed of a mixture of ultramarine blue and alizarin crimson. The stems are composed of mixtures of yellow and blue and yellow and black.

4. Next, I paint in the background around the flowers letting the green-ochre color slightly overlap the purple edges.

5. With a blending brush, I smooth out the background. I take a small sable brush dipped in black paint and pick out the shadows of the top flower. With another sable, I add white to the original purple mixture and begin to paint in the light areas on the same iris.

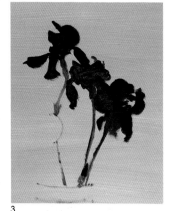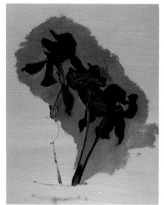

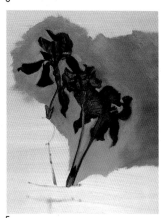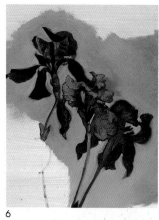

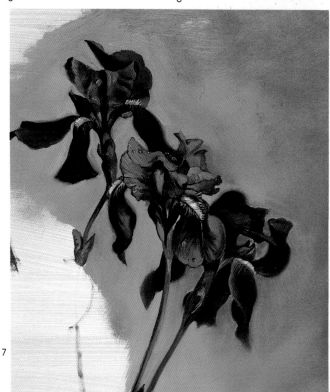

6. I paint the middle iris the same way as the top iris; but because it is more blue than the other flowers, I add blue to white when I paint in the light areas.

7. The third iris is rendered just like the others. Then, I take a small sable brush and touch in the white and yellow fuzz on all three irises. To keep this area soft, I use a dry bristle brush to blend and diffuse the edges. With my smallest round sable, I also add little drops of water to the iris petals. The drops are created by using three tones: a darker tone for the cast shadow, pure white for the highlight, and a tone somewhat lighter than the petal color for the reflection.

8. I add more irises to the bouquet using the same procedure as before. As I paint in the flowers, I continue to add background color.

9. The background is blended and made smooth, and the rest of the irises are painted.

10. A blue variety of iris is added to the bouquet, and I mix their basic color using must less alizarin crimson. A mixture of blue and white is used for the blue irises' highlights.

11. Details such as highlights and drops of dew are added to the flowers, and the background brushstrokes are blended smooth. I try to distinguish between the flowers on the left side that are in the light and the flowers on the right side that are in shadow.

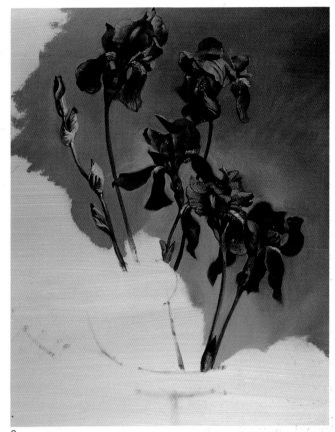

8

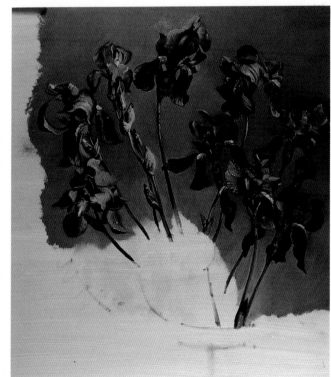

9

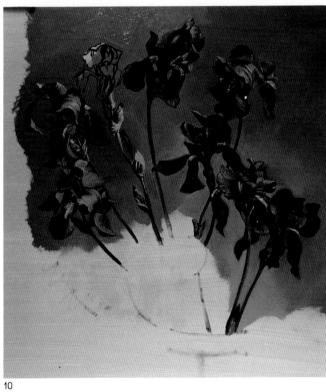

10

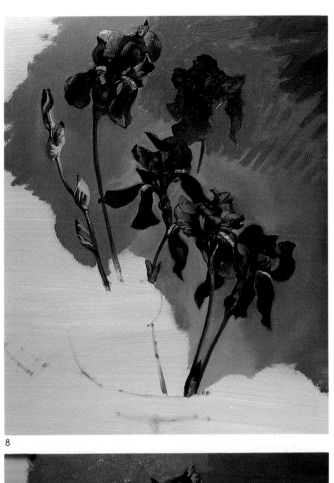

11

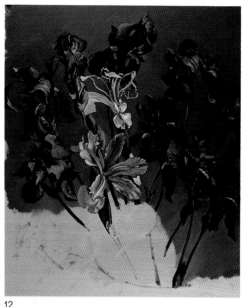

12

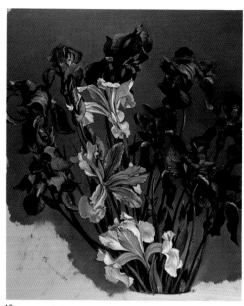

13

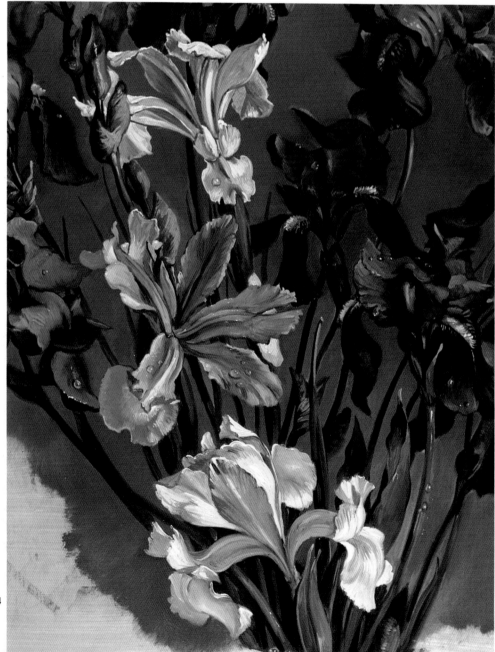

14

12. White and lavender irises are added to the picture. The top flower shows the beginning stage where I have drawn in the iris's outline with white paint. The lavender flower below it shows the second step where shades of grayed lavender color have been applied to indicate shadow areas.

13. One more white iris is added to the bouquet, and this section of the painting is almost finished.

14. This close-up of the irises shows the veins and ridges in the flower petals as well as a closer look at the water drops. Because the water drops are transparent, only the highlight, reflection, and cast shadow are rendered—the color beneath the water drop serves as its color.

CERAMIC VASE AND STRAW BASKET

15. Using a ruler and measuring from the sides, I draw in the outline for the iris vase. The basic color of the basket is laid in with a transparent burnt umber.

16. I take one of the irises out of the vase and lay it on the table top and then paint the background around it.

17. With a blending brush, I smooth out the background colors and add details of the veins, ridges, and yellow fuzz to the iris petals.

18. The ceramic vase is painted in roughly to show the light area, the dark accent of the shadow next to the light area, and the shaded area to the right.

19. The various tones of the vase are blended with a large, dry blending brush; its edges are kept soft against the background.

20. After the vase is dry I start on it again, this time to intensify the suggestion of a hard surface. The vase's glossy texture is created by using heavy white outlights and then blending them. This

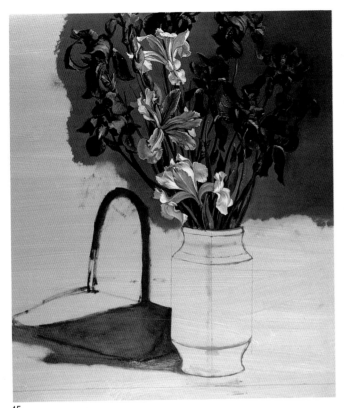

Transparent textures are rendered with almost no paint, just shadow and highlight.

15

16

17

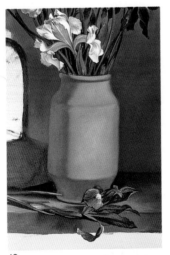

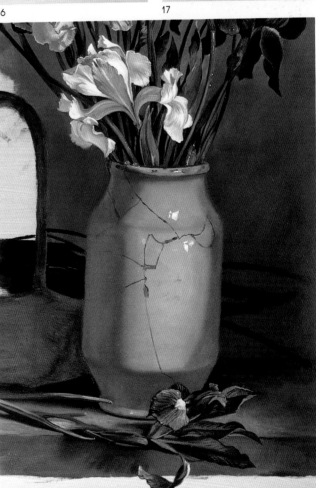

18

19

procedure is done two or three times until the degree of glossiness is satisfactory. **21.** The colors of the vase are blended a second time, and I add the cracks. The cracks are made by applying a dark line of color first, followed by a lighter tone to show the angle of the light. Bold impasto highlights create a light-reflective look.

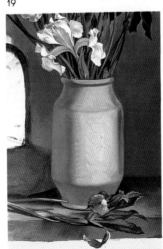

20

21

22

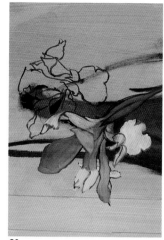

23

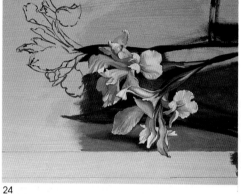

24

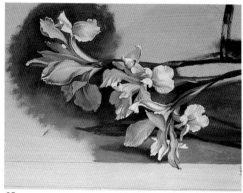

25

YELLOW IRISES

22. A horizontal flower arrangement is added to the composition. A sickle's point is turned inward to round out the corner of the composition and pull the eye back into the picture.

23. I draw in the yellow irises with burnt umber and then fill in the light areas with yellow and the shadow areas with gray mixed from black and white.

24. Details of light and shadow are laid in with small sable brushes. The shadows are accented with gray and the addition of burnt umber or black; the highlights are white; and burnt sienna mixed with yellow is added for the redder tones in the iris.

25. A third yellow iris is added and a thin, transparent background is added for contrast. The burnt umber tone is a middle value and is used because the final background is still undetermined.

26. The rest of the yellow irises and the surrounding background are painted in.

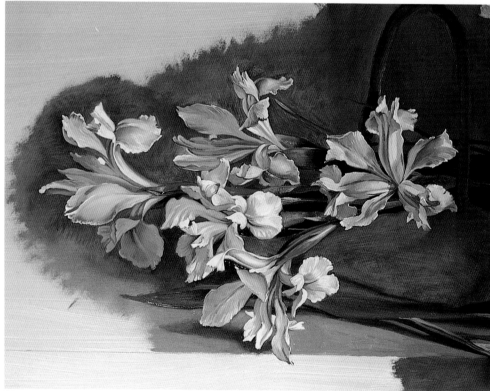

26

STRAW BASKET

27. A thin coat of medium is laid in over the dry basket, and the woven straw pattern is drawn in with burnt umber and a small sable.

28. For the basket's straw pattern, a diverse group of light tones are mixed using tints of burnt umber, burnt sienna, yellow ochre, and black and white.

29. To complete the basket, the dark areas are stated with burnt umber and black. The part of the handle closest to the viewer is kept in sharp focus while the side of the handle delicately fades into the background—a sfumato effect.

CERAMIC VASE

30. A thin coat of medium is laid over the dry vase and I start to render the vase's design.

31. Once the design is completed, I very lightly blend the adjacent colors to make the design appear to "belong" to the vase. Beads of water are added; they are elongated to suggest the effect of gravity.

32. With dark colors I draw in the sickle and its cast shadow.

33. The shadow area is blended with a blending brush, and the sickle's details are painted in with small sables.

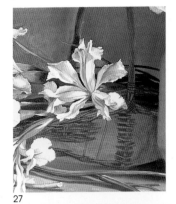

27

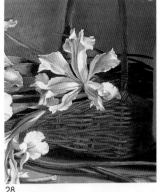

28

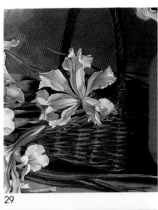

29

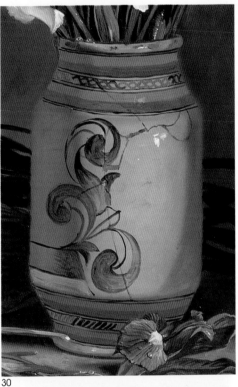

30

31

32

33

34

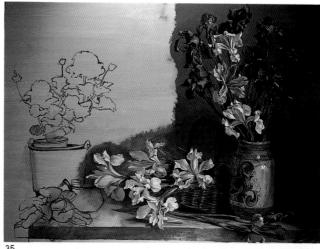

35

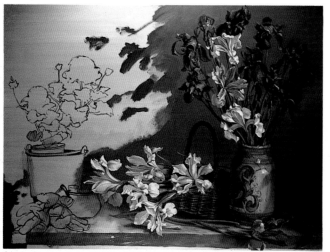

36

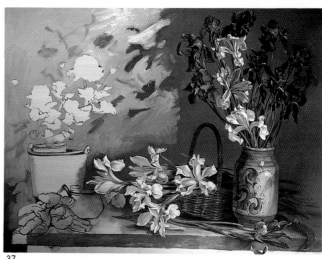

37

A thin coat
of medium
applied over
a dry surface
enables the
subsequent
layers of paint
to blend into
the first dry coat
and not show a
break between
applications.

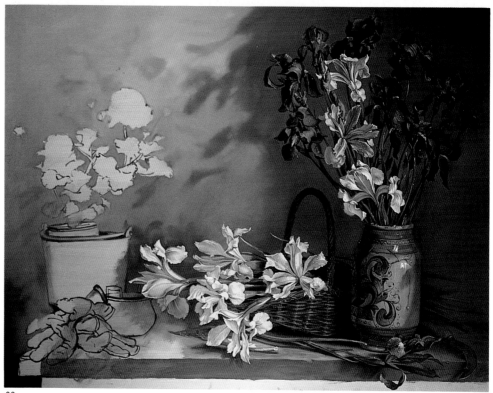

38

BACKGROUND

34. At this point, I sketch out the rest of the picture. On the left, I add an old pair of leather gloves, which I think lends a contemporary touch to the picture. I also add a copper pot and geraniums and plan to add pansies in the foreground. Leaf shadows on the wall round out the composition.

35. Using burnt umber, I outline the flowers and the rest of the painting.

36. I put medium over the dry background so that I can blend in the new applications of color with the dry paint underneath. I boldly paint in shadows of leaves over the background.

37. The light tone of the background is laid in with heavy paint.

38. Using a large, dry blending brush and big strokes, I smooth the background colors together until all of the shapes are soft like shadows.

GERANIUM

39. The geranium is laid in with a flat tone, made up of a mixture of vermilion and alizarin crimson.

40. Basically using the same procedure as I did for the iris, I draw in the shapes of the geranium petals and shadows, but this time I use a mixture of alizarin crimson and black. Light areas are created by adding white to the original mixture of vermilion and alizarin crimson.

41. At this stage, the geranium is finished. The lighter petals are detailed with subtle value variations, but the shadowed, darker petals are all the same value to create a contrast with the light areas.

42. I paint in the leaves with a mixture of chrome yellow and black. The light areas contain more yellow and the shadowed areas more black.

43. I sharpen the veins and edges of the leaves with small brush strokes and accentuate the darks and highlights.

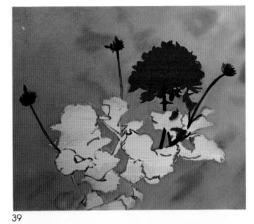

39

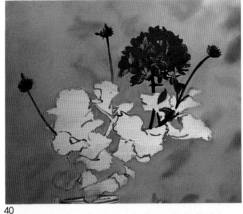

40

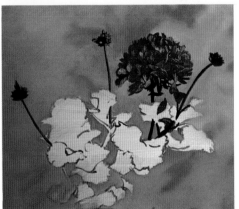

41

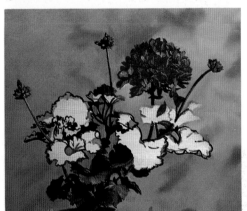

42

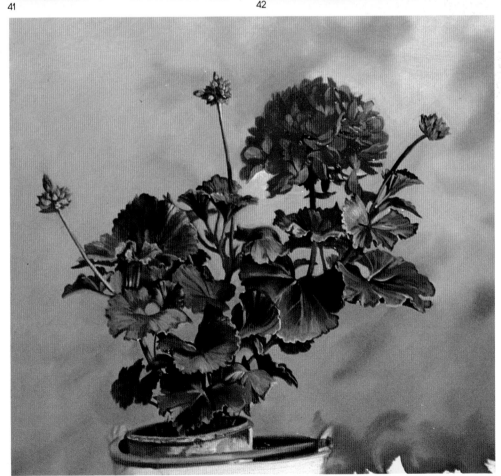

43

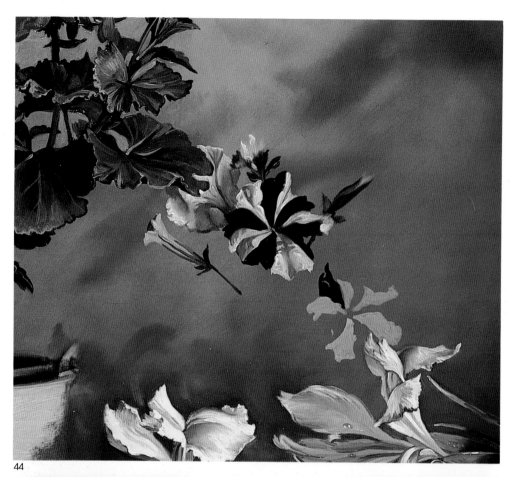

44

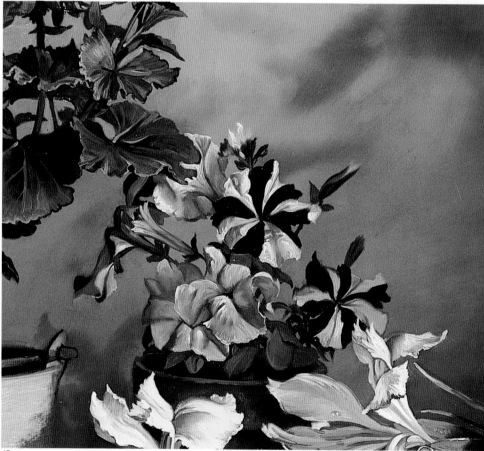

45

PETUNIAS

44. Although I had anticipated pansies, petunias arrive at the studio by mistake. I decide to include them in the background in half shadow. The lower flower shows how I created the petunia from two basic tones. The middle flower shows the white part rendered with light and dark tones, but the dark part of the flower is so dark that no light at all is reflected.

45. I paint in the rest of the petunias but keep the highlights subdued to keep them in the background.

OLD LEATHER GLOVES

46. I lay in the dark shadow of the leather gloves with a thin mixture of burnt umber and black.

47. A mixture of yellow ochre, burnt umber, and white is used for the middle tone of the light area.

48. The darker parts of the gloves are painted in with black. I use Naples yellow and white for the highlights.

49. I add gray to the worn parts of the fingers and, with my smallest sable brushes, draw in all the small cracks and rough places.

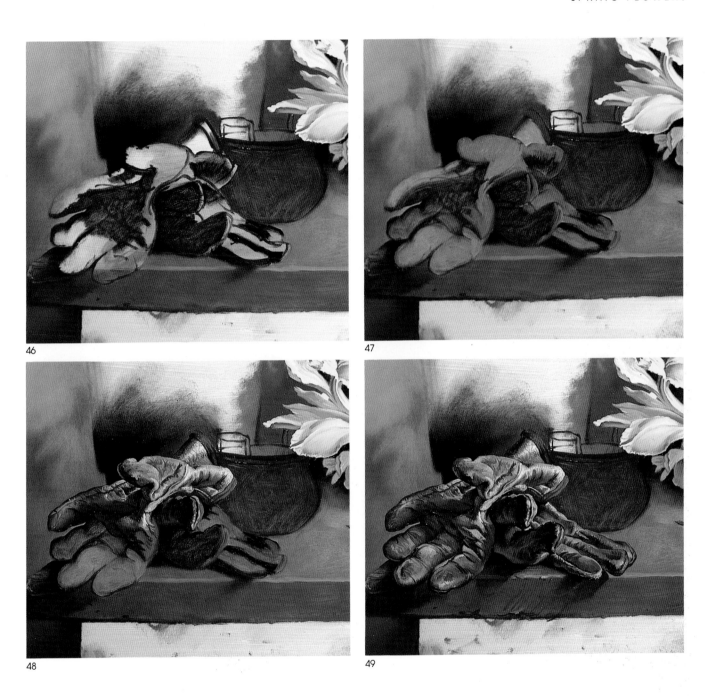

46

47

48

49

Some objects are so dark and softly
textured that no light is reflected
and shadows are not discernible.

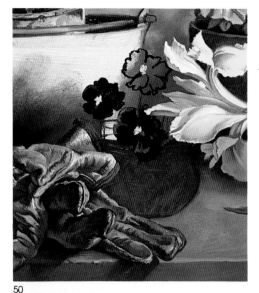

50

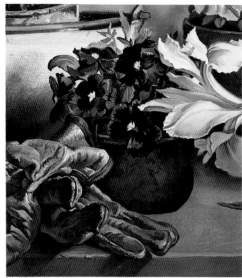

51

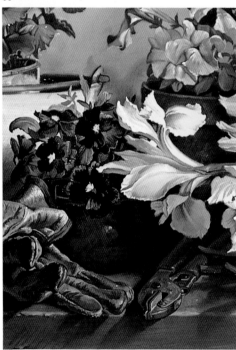

52

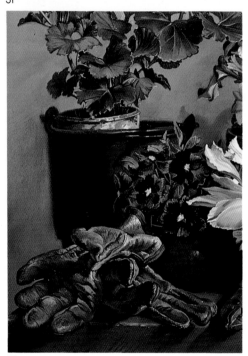

53

PANSIES

50. I lay in the solid dark tones of the pansies with a mixture of Thalo blue, black, and alizarin crimson. Their color is so dark that shadows do not show, so only a few highlights are added. The rims of the gloves are vermilion, but the shaded areas of the rim are a mixture of vermilion and black.

51. The remaining pansies are painted in.

COPPER POT AND CAST IRON POT

52. I lay in the copper pot with a flat tone of burnt sienna. Over this sienna base, I add several layers of burnt sienna mixed with black. This mottled effect suggests the texture of weathered copper. Note that only the bright, sharp highlight tells us the copper pot is metal. As a contemporary touch, I draw in an outline of a pair of garden snippers. It is created from a variety of grays. Note the diffused white highlights of the plastic handles.

53. The large cast iron pot in the back is rendered. Although it is metal, its highlight is dull because it is in shadow and because its texture is dull and matte. To intensify and unify the shadow surrounding the snippers and small copper pot, I glaze it with a thin coat of medium and black.

WEATHERED WOOD

54. The shadow and wood under the table are roughed in with a fairly large bristle brush.

55. The area under the table ledge is blended smooth, and the cast shadows are rendered with subtle, soft edges.

56. Over the medium brown value of the table, I brush in the darks and lights that are characteristic of the rough-textured wood.

The highlight of a metal object must be kept dull and low key if it is in shadow.

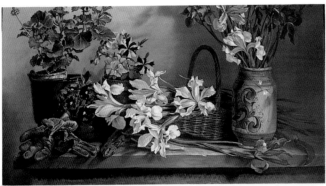

54

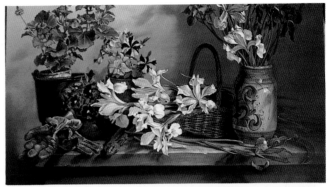

55

56

BUTTERFLY

57. A butterfly is added to catch the light, which also helps push the shadows back and create a sense of depth. To render the butterfly, I brush in a coat of medium in the intended area and then copy its colors and form from a book. The colors are laid in flat; the details are applied with a series of little dots and dashes.

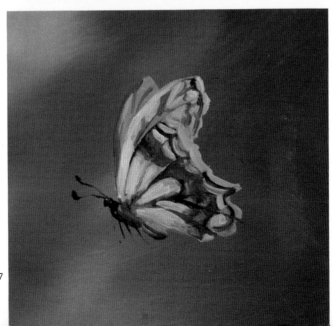

57

GARDEN VEGETABLES

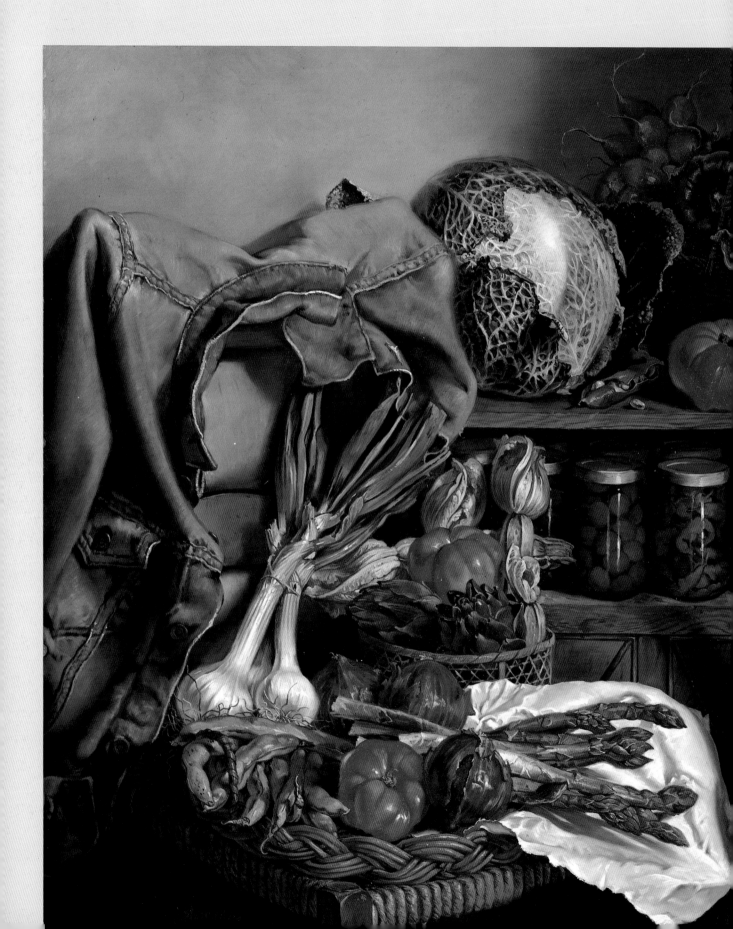

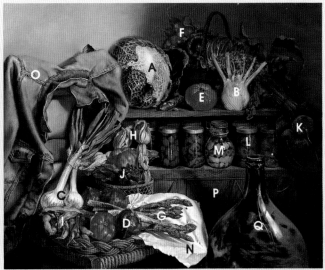

GARDEN VEGETABLES, oil on panel, 39″ × 31½″ (99.06 × 80.01 cm).

TEXTURES

A. *Cabbage*

B. *Fennel*

C. *White onions*

D. *Red onions*

E. *Tomatoes*

F. *Radishes*

G. *Asparagus*

H. *Zucchini flowers*

I. *Green beans*

J. *Artichokes*

K. *Beets*

L. *Colored glass*

M. *Glass jars*

N. *Paper*

O. *Denim*

P. *Wooden shelf*

Q. *Glass wine bottle*

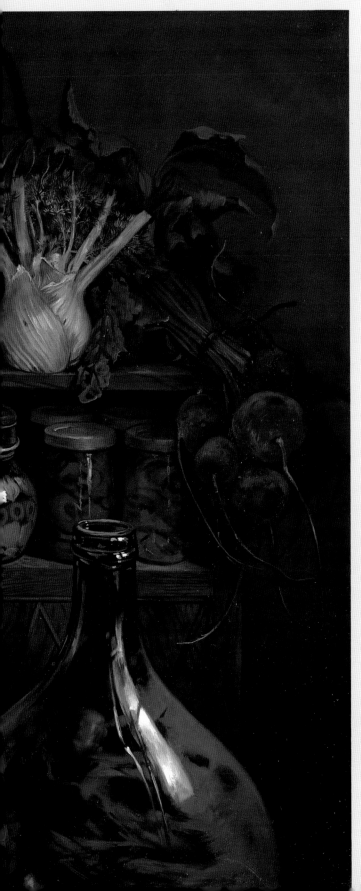

COMPOSITION SKETCHES

1. I place the composition slightly below eye level in order to see more of the vegetables. I feel that there is too much space to the left of the chair.

2. Here, I tighten up the picture by moving in closer.

ASPARAGUS, RED ONIONS, AND PAPER

3. On a gessoed Masonite panel, I draw in the composition using small sables and burnt umber.

4. The paper under the asparagus is laid in with a flat light gray. The asparagus is painted more transparently, with a mixture of alizarin crimson and a green mixed from chrome yellow and black.

5. Using only black paint, I draw in the contour of the asparagus heads and stalks. The red Spanish onions are laid in with a flat layer of alizarin crimson.

6. I start painting in the lighter areas of the asparagus, varying between a lavender and a green. The very lightest tones are composed of white mixed with a tint of yellow ochre.

7. The asparagus is completed by carefully describing each form with contrasting tones: dark against light and light against dark.

ZUCCHINI FLOWERS

8. The zucchini flowers must be painted immediately because they shrivel up after a few hours. Here, I scrub in a base tone of yellow ochre and burnt umber.

9. With a mixture of burnt umber and black, I draw in the basic forms and shadow areas of the zucchini flowers.

10. Using Naples yellow and white, I paint in the light tones with heavy paint.

11. The edges of the lights are blended softly against the background tone.

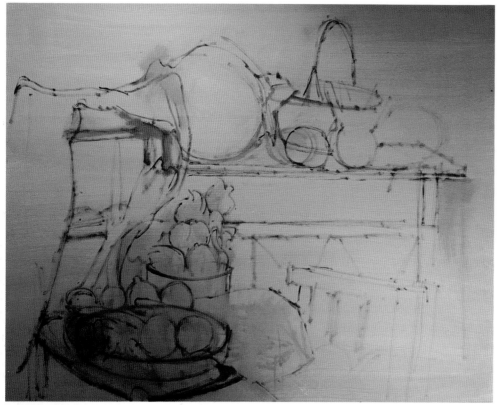

3

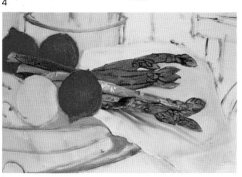

4

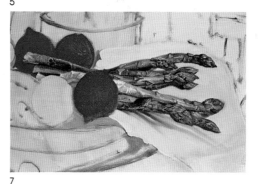

5

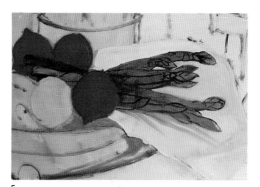

6

7

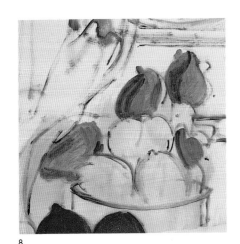

8

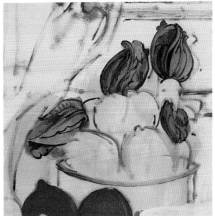

9

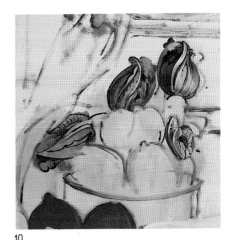

10

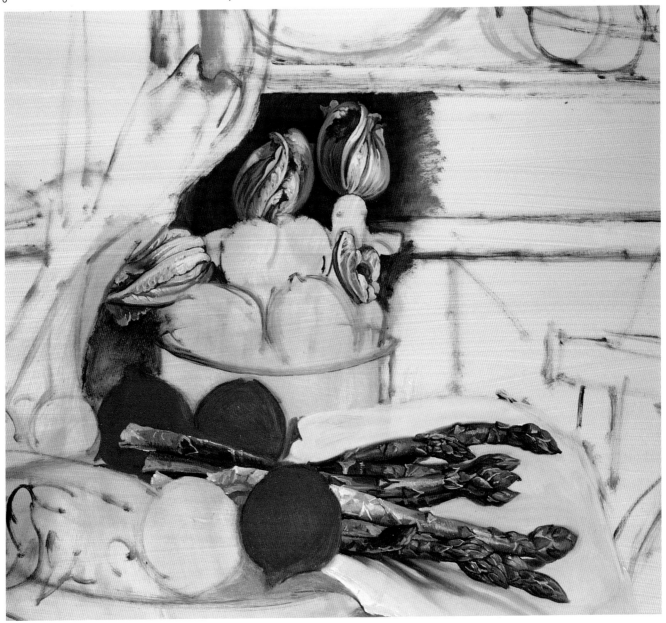

11

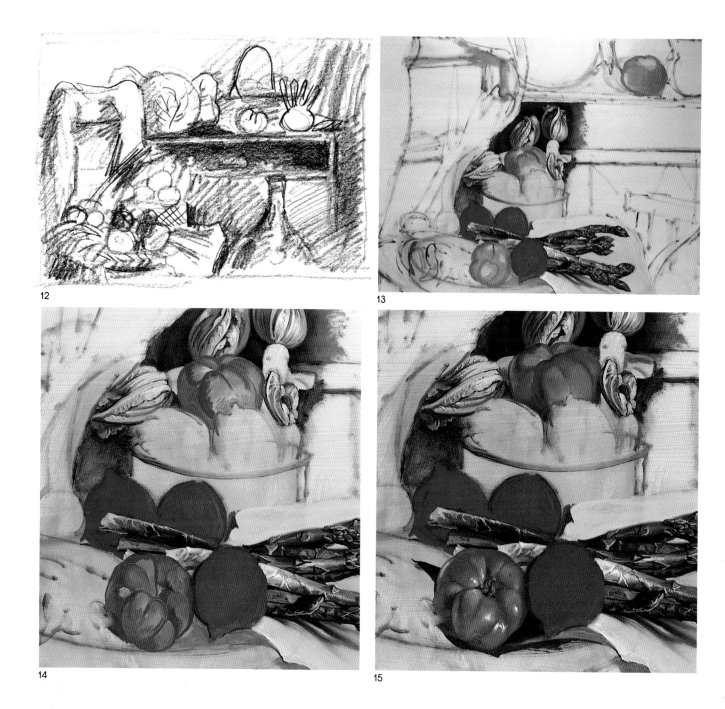

12

13

14

15

After an object or texture has been blended
to create a smooth surface, dark accents
and highlight areas must be redefined.

TOMATOES

12. I remove the wooden crate from the composition and substitute a large green wine bottle. I feel its sensual, curving form and glassy surface help the composition and make the picture more interesting.

13. With tones of yellow and red, I paint in the tomatoes.

14. Using pure vermilion, I lay in the shapes that make up each section of the tomato. The shadow areas are created by mixing alizarin crimson and burnt umber or black.

15. I blend each form with a blending brush and add the small blemishes with a small sable. Then I add white impasto highlights.

WHITE ONIONS

16. The other two tomatoes are finished similarly to the first one, with details and highlights to describe their particular form and the way the light hits them. I paint in the basic colors of the white onions, which are laid in with a light gray; the onion stalks are a mixture of chrome yellow, Prussian blue, and white.

17. Into the gray tone, I render the shadows and seams with black and a dark gray.

18. I blend the tones of the onion bulb and reinstate the dark and light accents. Pure white is used for the highlights.

19. I blend the onion colors a second time and repaint the light and dark accents. I add the tiny root hairs and paint in the stripes on the stems with my green mixture—of chrome yellow, Prussian blue, and white—and small sables.

20. Plain white or ultramarine blue and white highlights are added to the onion leaves. To tie the onion bunch together, I draw in a string with a small amount of paint and a small sable brush, laying in the cast shadows first, followed by the lines of green paint which gives the string its three-dimensional look.

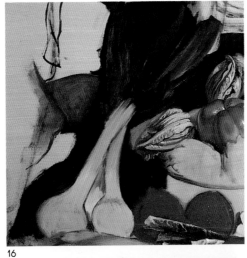

16

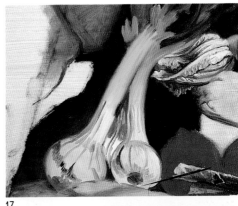

17

18

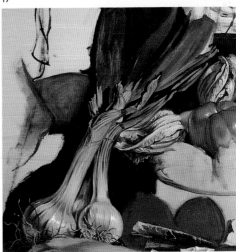

19

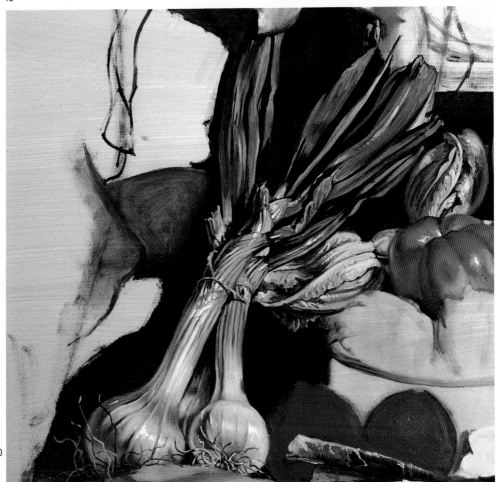

20

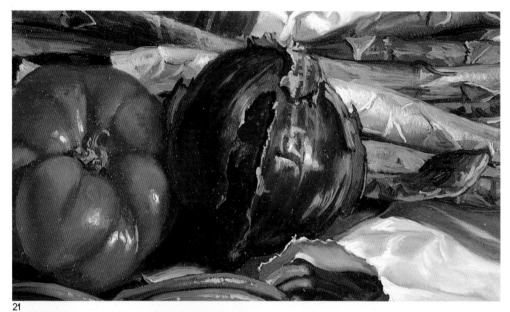

21

22

23

RED ONIONS

21. The red Spanish onions are rendered over the dry alizarin crimson underpainting. A coat of medium is applied and then a new thin coat of alizarin crimson. This is drawn into with black for shadows and white for highlights.

ARTICHOKES

22. The artichokes are rendered in the basket. First, I lay in a thin layer of alizarin crimson mixed with ultramarine blue. Then, a green mixed from chrome yellow and Prussian blue is used for the tips of the leaves. I blend the purple and green tones together; and with alizarin crimson and black, I draw in the shadows. I paint in reflections with vermilion and use white for a few highlights. Specific steps for painting an artichoke are given for the painting *The Broken Egg,* pages 138–139, steps 41–44.

GREEN BEANS

23. No secret to painting the beans: I draw them in first, then lay in a flat green of chrome yellow and black. The rounded forms are then explained with light, shadow, cast shadow, and highlight.

CABBAGE

24. The cabbage's three values of green are scrubbed in using mixtures of Prussian blue, chrome yellow, and white. I also apply some neutral-toned background color and let the edges overlap somewhat with the cabbage.
25. I begin drawing in the leaves with a dark green mixture. I add black to the basic light green color and paint in the cast shadows on the cabbage.

24

25

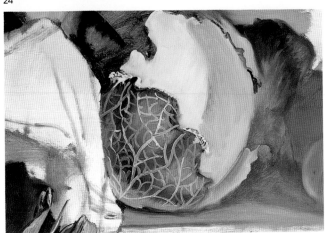

26

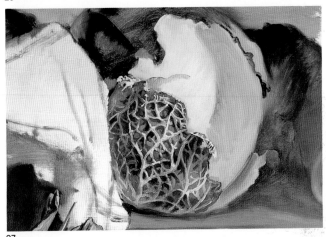

27

26. With chrome yellow, white, and a touch of the green mixture, I draw in the veins of the cabbage with heavy paint.

27. For each vein I also paint in a cast shadow with black. I lighten the bottom of the cabbage to show light reflected from the tabletop.

28. I carefully put in the rest of the cabbage veins. To diffuse the light, I stipple the highlight area with the flat edge of my blending brush. I smooth out the outside edges of the cabbage, softening the veins and making them less distinct.

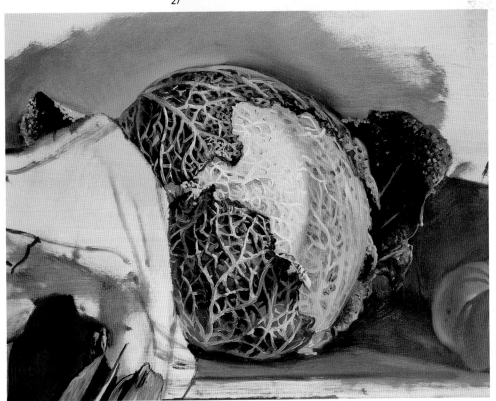

28

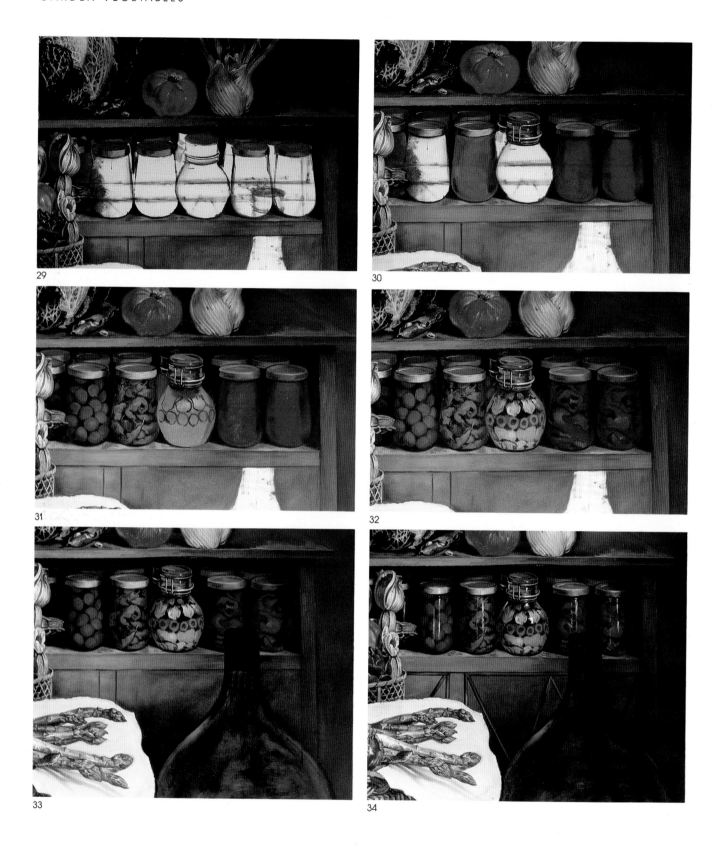

29

30

31

32

33

34

The texture of glass is an illusion.
The less a glass object is rendered,
the more transparent it seems.

FENNEL, GLASS JARS, AND WOODEN SHELF

29. I render the fennel in low-key tones of gray to keep it in shadow. I decide to add two rows of filled glass jars on the shelf. Using a bristle brush I lay in the tops of the jars with varying mixtures of black and white to indicate light and shadow areas.

30. I scrub in red tones for the red peppers and an olive tone—yellow ochre and black—for the green vegetables. With a mixture of black and white I paint in the glass tops. Touches of white impasto are used for the highlights.

31. With dark colors, I draw in each object in the jars.

32. To suggest form, light tones are added to the artichoke hearts and peppers.

33. With a soft oxhair blending brush, I smooth out the colors in the jars. The large wine bottle is laid in with a transparent Prussian blue that has been tinted with black.

34. I add highlights to the jars, keeping the shadowed edges diffused but their centers pure white. The highlight alone gives the impression of glass.

35. A coat of medium is applied to the wood area, then the lines of the wood are drawn in with burnt umber. The entire wood area is softened with a dry blending brush.

PAPER

36. A thin coat of medium and white is applied over the paper area. Into this wet surface, I use gray paint to lay in shadows found in the folds of the paper.

37. Using a small sable brush, I paint in details of the gray shadows. With another small brush, I place the white highlights. For the shadow cast from the green bottle, I use a thin application of very thin Prussian blue.

38. I blend together the lights and shadows of the paper, and then redefine the dark gray accent and highlight areas.

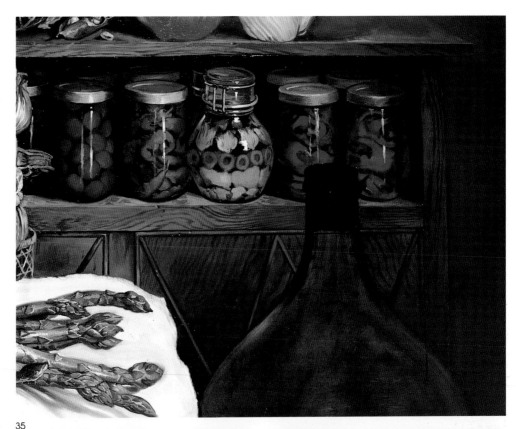

35

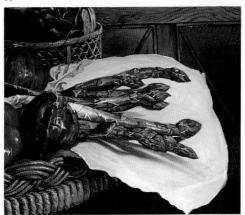

36

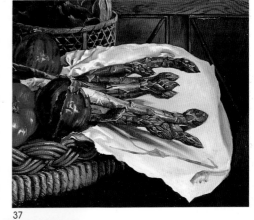

37

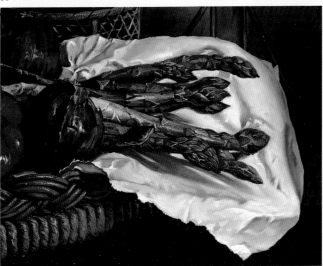

38

DENIM

39. I paint the jacket in two tones of blue: a mixture of ultramarine blue, white, and a touch of burnt umber for the light areas; the same mixture with black added for the shadow areas. Each fold of cloth is explained with highlights, reflection, and cast shadow.

40. The colors are blended together and softened with a blending brush.

41. On wet paint, the details of the stitching are drawn in with small sables.

42. To indicate the faded areas of the cloth, additional highlights are added and then blended in.

43. As before, over wet paint, metal buttons and small details are drawn in with small sables.

GLASS WINE BOTTLE

44. A coat of medium is painted over the bottle. Sharp dark tones are painted on the neck and lips of the bottle to indicate the hard, shiny texture of glass. Pure white highlights stress even more the highly reflective nature of glass. A gray is brushed in for the dusty area on the bottle using a mixture of black, white, and burnt umber.

39

40

41

42

43

45. A strong highlight of white tinted with blue is added and its edges softened. Then, a reflection of the asparagus and tomatoes is painted in on the surface of the glass and then blended.

46. As I continue to paint the bottle, I see my own reflection and decide to show its presence on the bottle; then it is softened with a dry brush. I also add more highlights: a pure white and a Prussian blue mixed with white.

BACKGROUND VEGETABLES

47. The vegetables in the basket on the top shelf are blocked in with various colors. Because they are in shadow, they are purposely kept dark.

48. The beets are painted in with dull tones of alizarin crimson, burnt umber, white, and some black. Their edges are kept soft against the background.

49. The red radicchio lettuce is rendered with alizarin crimson and black. Gray is used instead of white for the light area.

50. Radishes complete the basket. Remember that rendering objects in shadow is more difficult than rendering them in full light because contrast can't be used to define and describe form.

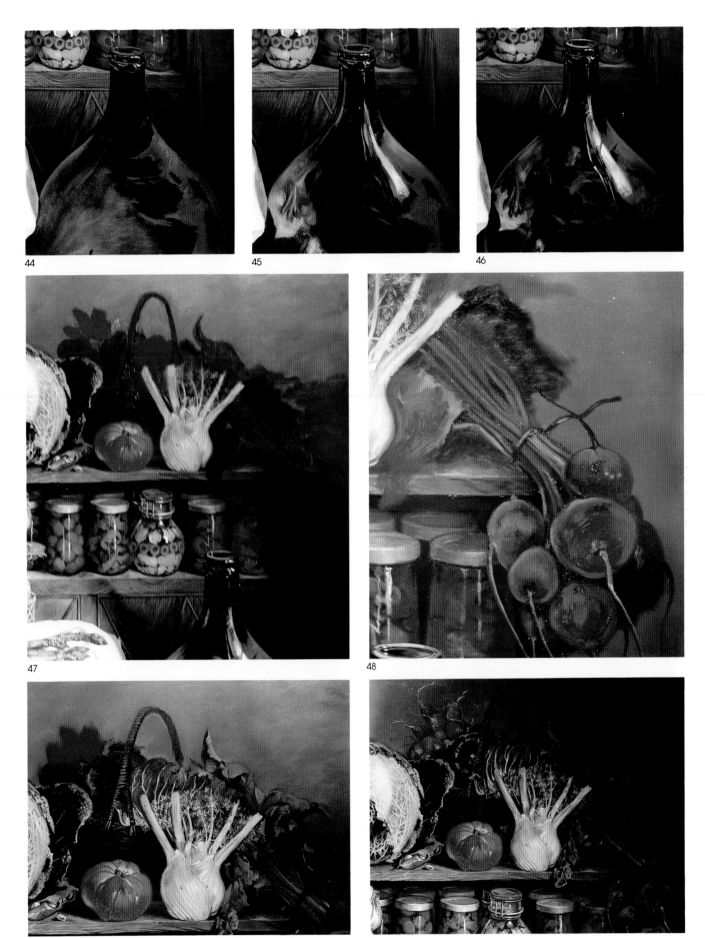

44

45

46

47

48

49

50

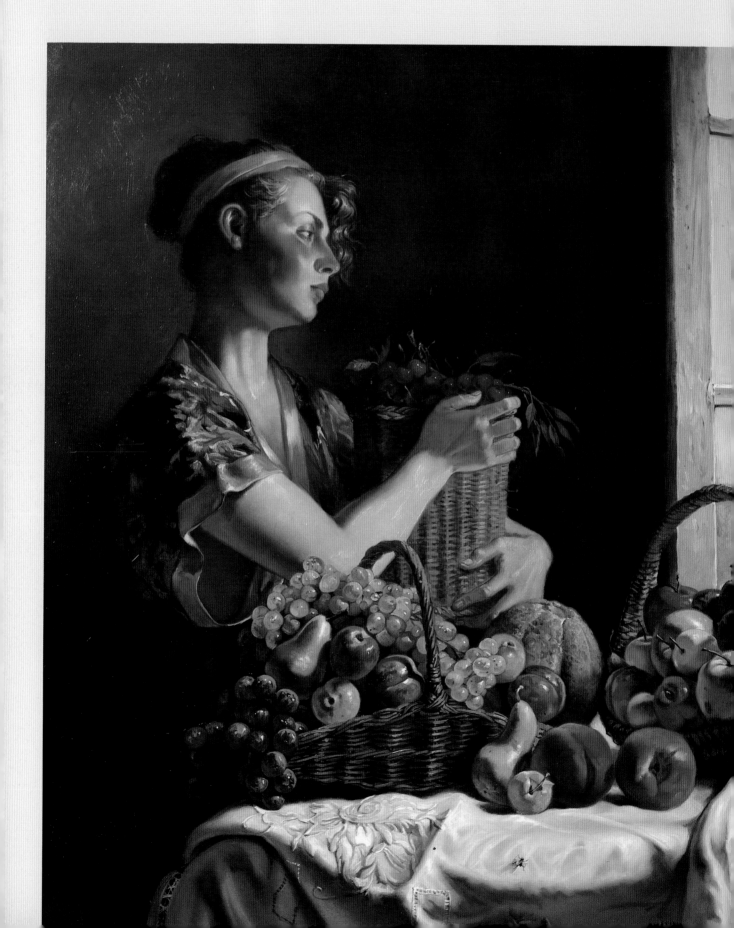

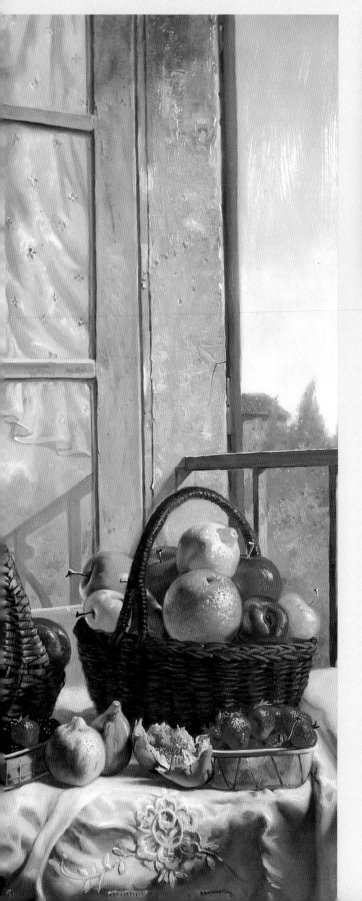

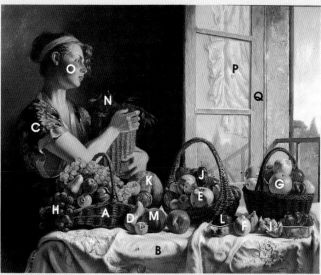

TABLE OF FRUIT, oil on panel, 39″ × 31½″ (99.06 × 80.01 cm).

TEXTURES

A. *Basket weave*

B. *Linen tablecloth*

C. *Silk kimono*

D. *Pears*

E. *Apples*

F. *Lemons*

G. *Orange*

H. *Grapes*

I. *Figs*

J. *Plums*

K. *Melon*

L. *Berries*

M. *Peaches*

N. *Cherries*

O. *Fleshtones*

P. *Embroidered cotton*

Q. *Wooden door frame*

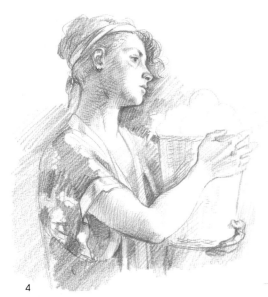

1

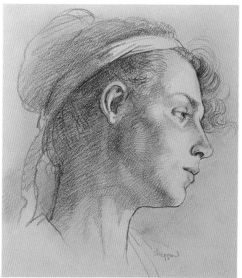

2

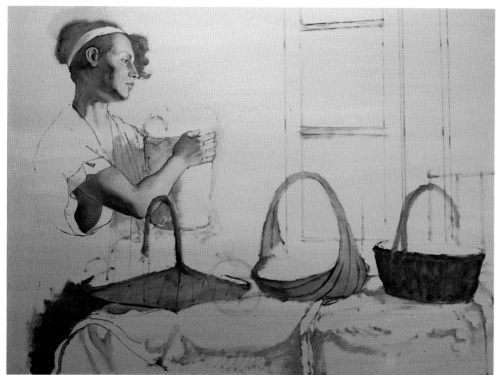

3

4

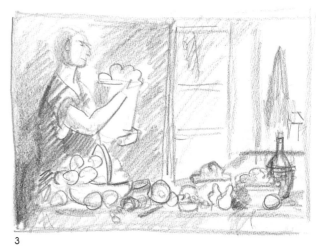

5

COMPOSITION SKETCHES

1. My first thoughts are put down in a tiny ink sketch: a woman holding a basket of fruit in front of a window and a table laden with assorted fruits.

2. Still thinking with my pen in hand, I draw a sketch indicating the attitude that I want the model to assume.

3. Here, I incorporate the figure into a horizontal composition, making the still life on the table become the center of interest and the figure secondary.

4. Before I go ahead with the actual painting, I make a drawing of the model from life in the intended pose.

5. A more detailed drawing is made of the head. I make it the actual size that I will use in the painting.

THE UNDERPAINTING

6. I trace the head from my drawing onto a Masonite panel. The figure is rendered in some detail with a mixture of burnt umber and white, except for the hair; it is laid in in a flat tone mixed with yellow ochre and black. This will be the base tone for blonde hair. The rest of the composition is drawn in with a burnt umber outline. The baskets are indicated with flat tones of the same neutral color.

6

7

8

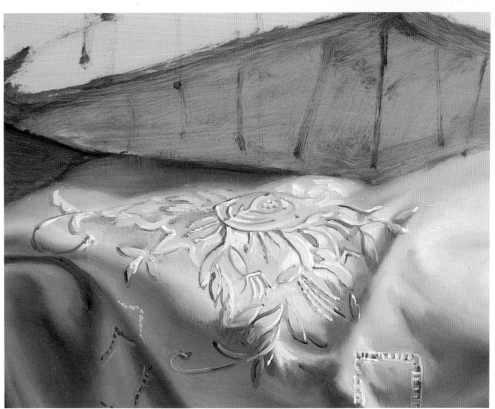

9

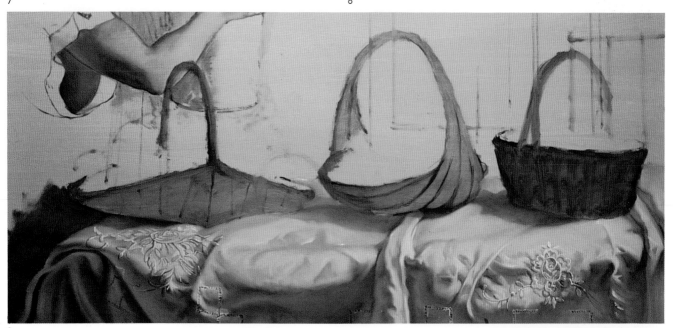

10

LINEN TABLECLOTH

7. I start the tablecloth with a thin coat of white. Into this tone I add shadows and cast shadow areas with different tones of gray mixed from black and white. While the paint is wet, the tones are then blended together with a dry blending brush.

8. Then because blending obscures details, I indicate highlights and shadow areas again. I then blend the area a second time. Note that highly resolved and modeled areas are often blended several times.

9. With small sable brushes, I draw in the raised pattern of the cloth using thick white paint for the highlights and dark gray for the shadows.

10. This detail shows how one side of the cloth's pattern catches the highlight and the other side shadow. Note that the pattern is painted to follow the forms of the folds.

11

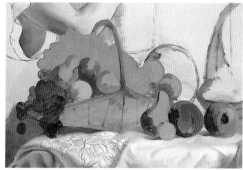

12

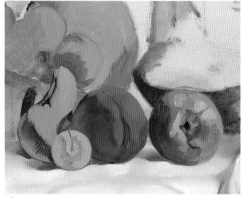

13

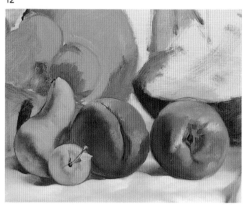

14

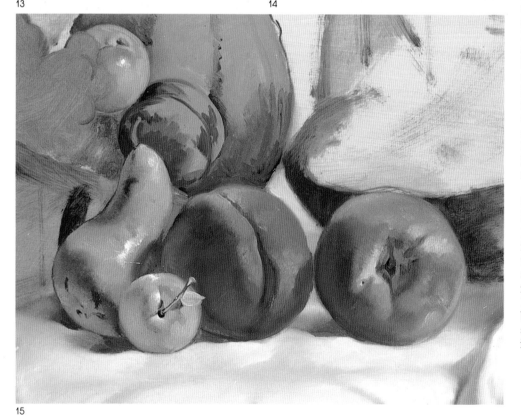

15

FRUIT BASKET 1

11. The fruit is sketched in inside and outside the contours of the basket.

12. I paint in flat tones of local color for the various fruits. Each kind of fruit, except for the grapes, is painted in with two tones: a light color for the highlight areas and a darker color for the shadow areas.

PEACHES, PLUM, AND PEAR

13. I begin to model the two peaches, plum, and pear. The various shades of observed color in the peach are brushed in; and the shadows on all four pieces of fruit are carefully placed.

14. To indicate peach fuzz, soft touches of gray are laid over the previous colors. Note that the grayed areas on the plum have sharp edges compared to the soft gray on the peaches. This sharpness suggests a shinier, smoother surface than that of the peach.

15. The colors of the fruits are blended with a dry blending brush. Highlights are added to the pear and plum, but the peaches, because of their soft, fuzzy texture, receive no highlight. The tight skin of the plum gets a sharp highlight; the pear's highlight is bright in the middle but has diffused edges.

GREEN GRAPES, PLUMS, PEAR, AND MELON

16. The same procedure is followed again for the fruit in the basket. To begin, the basic colors and shadows are marked in.

17. Next, the colors are blended, and highlights and shadows redefined. Then the individual grapes are outlined.

Texture can be explained by highlight: soft, fuzzy fruits have no highlight; smooth fruits have crisp highlights; and shiny, translucent fruits have very bright highlights.

18. Yellow ochre tones mixed with white and burnt umber define the melon.

19. After the various tones of the melon are blended, I add the texture of the ridges with a small sable and very thick paint. In a few areas, I indicate the cast shadows created by the ridges of the melon. Then I touch in with chrome yellow the light reflection on the grapes. In this case it is the light passing through the grapes that makes the reflection so bright.

20. The frosted, opaque area on the grapes is only seen on the highlighted side. I dab this in with a mixture of white, a touch of Thalo blue, and black.

21. To suggest their moistness, little dots of highlights are touched in on the grapes. These should remain small and subtle and not be overdone.

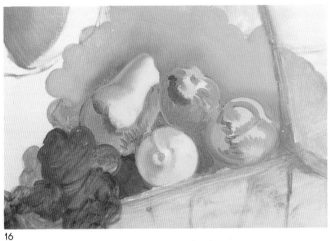

16

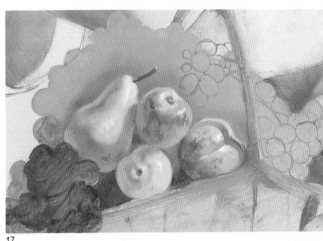

17

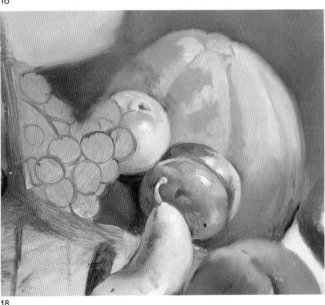

18

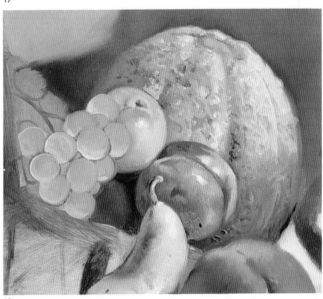

19

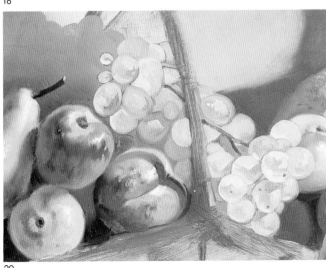

20

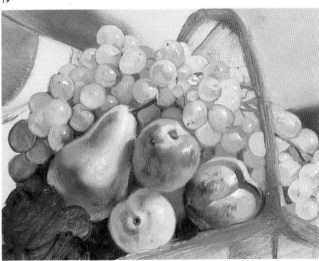

21

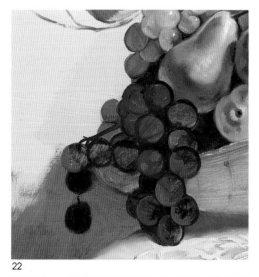

22

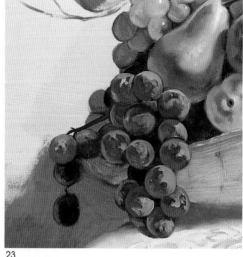

23

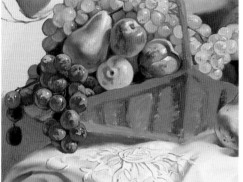

24

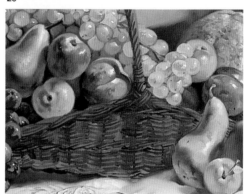

25

26

PURPLE GRAPES

22. With alizarin crimson and black, I draw in the individual shapes of the purple grapes. Note the black outline around the perimeters of the grapes.

23. To indicate light passing through a deep black-red skin, the reflections of the purple grape are indicated with a bright vermilion. A blue gray is used to suggest the frosty, opaque areas.

24. Sharp, small highlights that reflect the light are added to each grape. To indicate its basic form, areas of light and shade are laid in on the basket.

BASKET WEAVE 1

25. With burnt umber, I draw in the basic pattern of the weave. For the lighter straw, I use various mixtures of yellow ochre, burnt umber, black, and white.

26. To finish the basket, I add highlights of yellow ochre and white.

FRUIT BASKET 2

27. The fruit in the middle basket are sketched in. I lay in yellow paint on the yellow fruit and indicate shaded areas with a middle-tone gray.

28. The basic colors of the other fruits are laid in: first the green fruits, then the red, and finally the purple plums. They are painted in this sequence, from light to dark, in order to keep the brushes clean so as not to muddy the lighter colors.

29. The colors of the apple are blended and remodeled to suggest an apple's roundness. To soften the area, yellow tones are added to the shadow reflection.

30. The apple is refined by adding its diffused highlight and little dabs of brown paint for the individual blemishes. I also add the shadow accents and shadows on the red apples and plums at this stage.

31. The colors of the pear, red apples, and plums are blended. Dark accents and highlights are then touched in over wet paint.

32. The green apple is blended with a blending brush and shadows and highlights are added. An opaque ultramarine blue mixed with white is applied to the plums to indicate the frosty opaqueness of the skin. This opaque light is contrasted against the dark transparent undertone of purple.

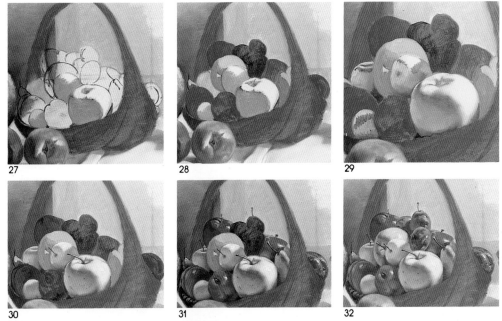

27

28

29

30

31

32

33

BASKET WEAVE 2

33. The complex weave of the middle basket is drawn in with a mixture of burnt umber and black.

34. The basket is rendered using the same procedure as the first basket: Burnt umber and mixtures of burnt umber, black, and white form the dark and light pattern of the weave; and a finishing touch of yellow ochre and white make up the highlighted areas.

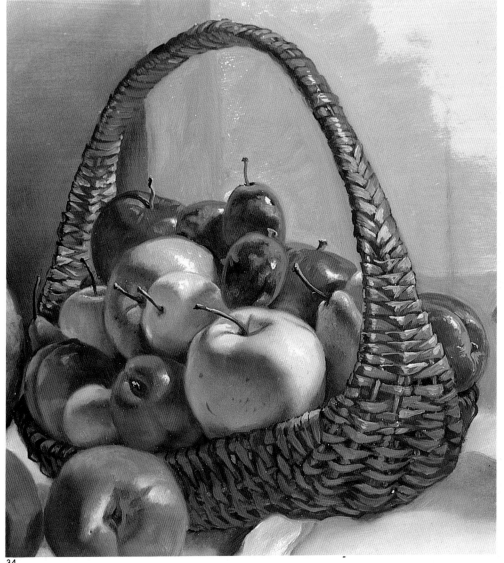

34

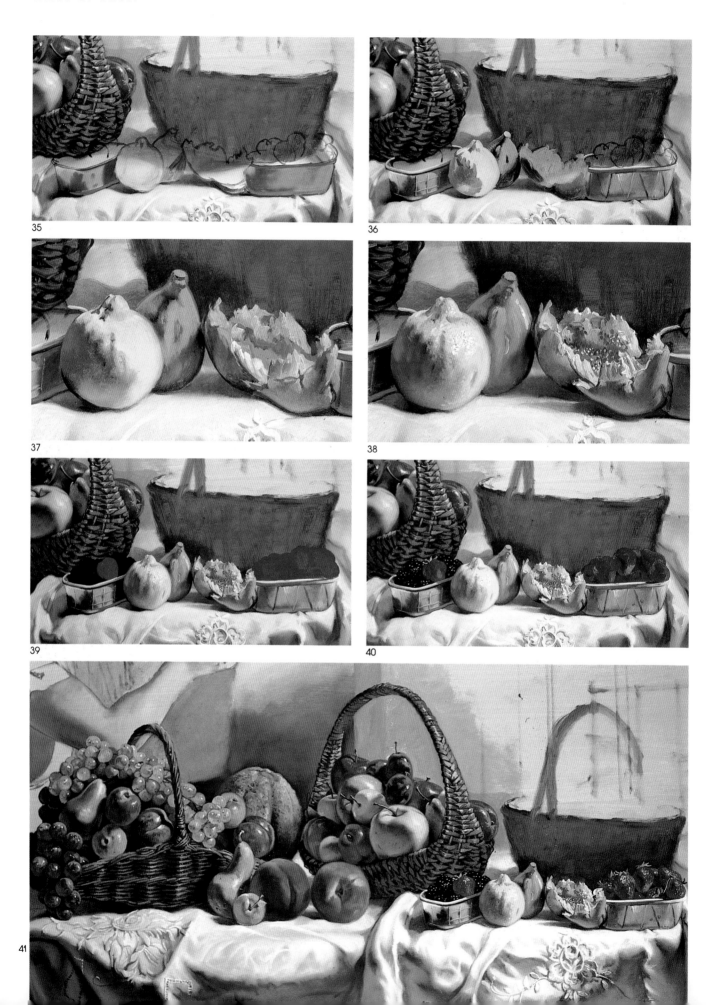

35

36

37

38

39

40

41

FIGS, BERRIES, AND LEMON

35. Outlines in black are drawn for the figs, berries, and lemon. I use black this time instead of burnt umber because the umber would leave a brown stain on the white linen tablecloth.

36. The figs and lemon are blocked in with various tones of local color, and the white plastic containers for the berries are laid in with mixtures of black and white and refined with highlights and dark accents.

37. The shapes of the lemon and figs are carefully described and rendered by blending, then refined with areas of light and shade.

38. Details and highlights are added to the figs. The speckled highlight on the lemon is dotted in with a small sable brush loaded with heavy paint. This heavy impasto suggests the rough texture of the lemon. Note also the impasto on the interior landscape of the fig.

39. Several shades of red are laid in for the strawberries. The blackberries are painted solid with a mixture of ultramarine blue and black.

40. Shadow areas are indicated on the strawberries and each berry is defined with black mixed with some red. The raspberries are explained solely with highlights, but the solid mass of the blackberries is dotted in with many highlights. This profusion describes the many segments of the blackberries but also their dark, lustrous surface. I also paint a few small leaves in the center of the strawberry.

LINEN TABLECLOTH

41. Diffused highlights are put in on the tablecloth, and leaves complete the strawberries. A *velatura*, tinted with white, is brushed over the entire linen tablecloth and then smoothed with a blending brush. The *velatura* unites the tones of the tablecloth, giving it a frosted look.

42

43

44

45

46

FRUIT BASKET 2

42. The contours of the fruit are sketched in and background tones are laid in around the fruit shapes.

43. The shaded areas of the fruit are applied over the various fruit colors. Note that the edges of the fruit overlap the background.

44. Each piece of fruit is modeled by building up light, shadow, reflection, and cast shadow areas and then blending them with a large, dry bristle brush.

45. The basket weave is completed with highlights and dark accents. All highlights are applied with the idea of suggesting a specific texture. Only the orange remains without its highlight.

46. With little circles of white impasto, I paint in the highlights of the orange. The openings between the circles of impasto paint are used to suggest the roughness of the orange's skin.

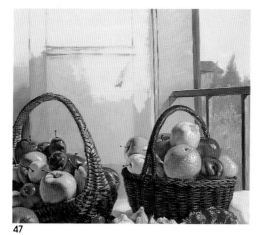

47

48

49

50

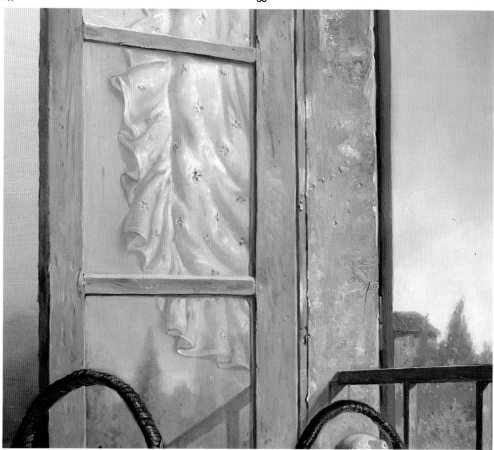

51

EMBROIDERED COTTON CURTAIN AND WOODEN DOOR FRAME

47. The landscape outside of the window is painted in with light tones. White is added to every color to create a sense of distance and atmosphere.

48. The heavy impasto texture of the door frame is applied with a palette knife and left rough.

49. The folds of the curtain behind the window are brushed in softly with mixtures of black and white and then blended with the blending brush. The area is kept very soft to suggest that the curtain is behind the glass. The railing and trees are rendered with soft edges to suggest reflected images.

50. The embroidery details are drawn into the curtain while it is wet. I do this by applying the darker color to indented areas of the embroidery and lighter color to areas where the embroidery is raised.

51. Once the curtain is dry, a coat of medium combined with a tint of blue is laid in over the entire windowpane and then blended. Note that the reflection of the trees extends into the lower part of the curtain. This suggests a thickness of glass in front of the curtains.

FLESHTONES

52. The face is glazed with tones of gray for the light area and burnt umber for the shadow areas. Note that the underpainting shows through at this early stage.

53. Into the wet gray tones, yellow ochre plus white and tones of red are laid in.

54. These various colors are then blended and I redefine highlight and shadow areas. This process is repeated until the forms and colors are exact.

55. The face is completed with the final addition of dark accents and highlights. I use Naples yellow for the highlights of the hair.

52

53

54

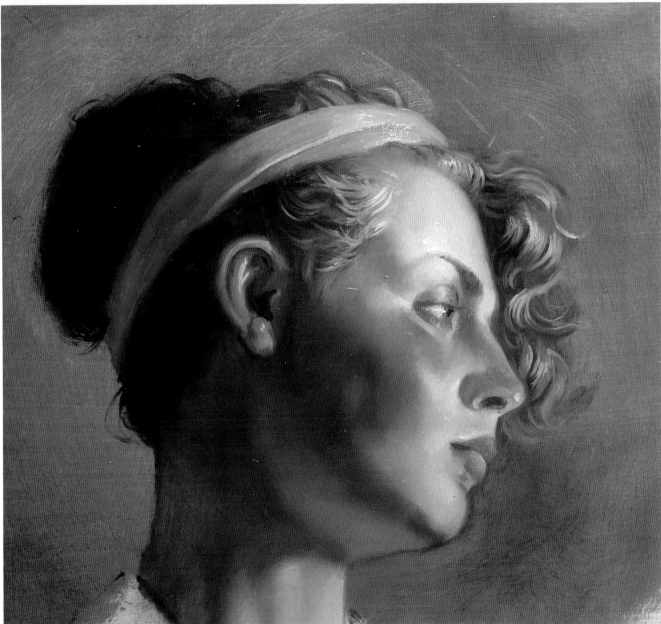

55

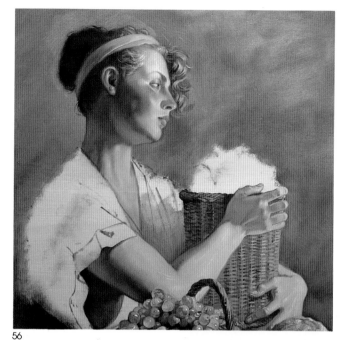

56

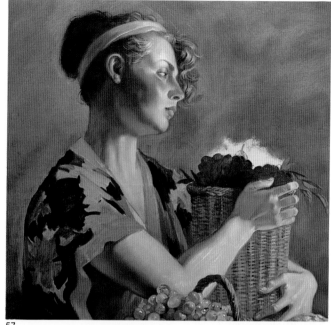

57

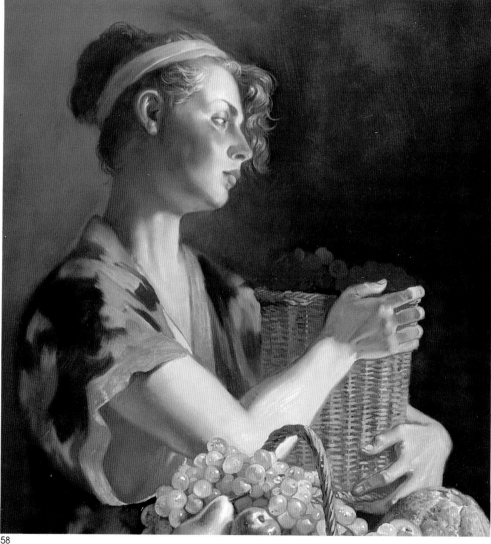

58

56. The arms and hands are rendered exactly like the face. The basket is rendered similarly to those previously described.

57. Flat areas of color are laid in for the designs on the silk kimono. The cherries are described with a flat tone mixed with reds and a touch of black.

58. A thin coat of wet medium is painted over the entire background wall. The darker part is kept more transparent than the lighter part, which is opaque. Note that the opaque area behind the women's head is kept light to set off her profile, while the transparent area is kept dark and glowing to add a sense of richness and depth. I take time to keep all of the edges of the model and fruits soft against the background. To do this I sometimes have to add new color to an object or area that is already dry and then reblend the area with a blending brush.

CHERRIES AND SILK KIMONO

59. Over the flat undertone, I render the cherries with reflections and highlights. Then, with small sables, I add the leaves and stems into the wet background.

60. I blend the colors on the kimono and then draw in the details of the pattern with fresh paint. The shadow on the cuff is put in.

61. Impasto Naples yellow highlights are added to the gold trim of the kimono and their edges blended in. The colorful pattern of the silk is once again blended to create soft edges between tones of color.

59

60

61

Transparent, thin-skinned fruits, such as cherries or grapes, are rendered primarily with reflections and highlight areas.

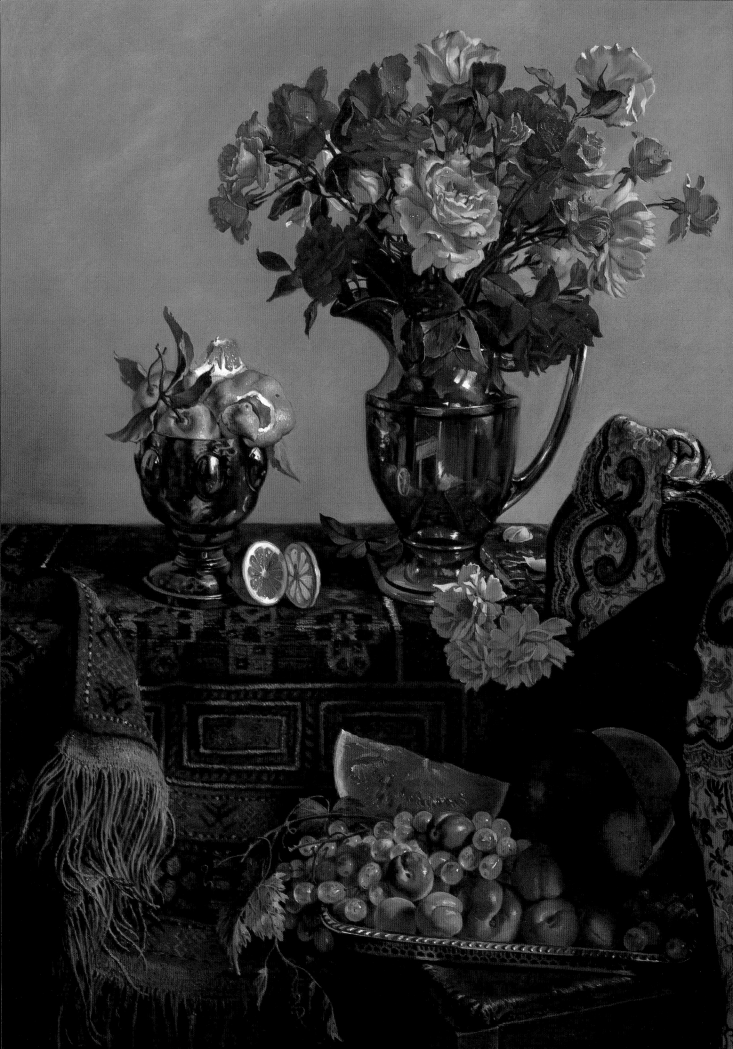

SILVER PITCHER

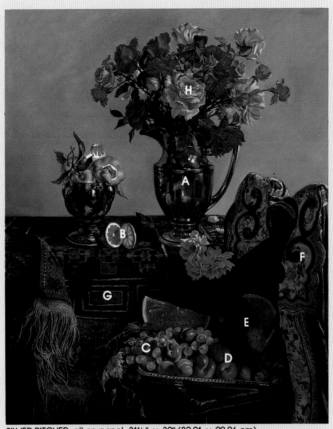

SILVER PITCHER, oil on panel, 31½″ × 39″ (80.01 × 99.06 cm).

TEXTURES

A. *Silver*

B. *Limes*

C. *Green grapes*

D. *Plums*

E. *Watermelon*

F. *Embroidered silk*

G. *Oriental rug*

H. *Roses*

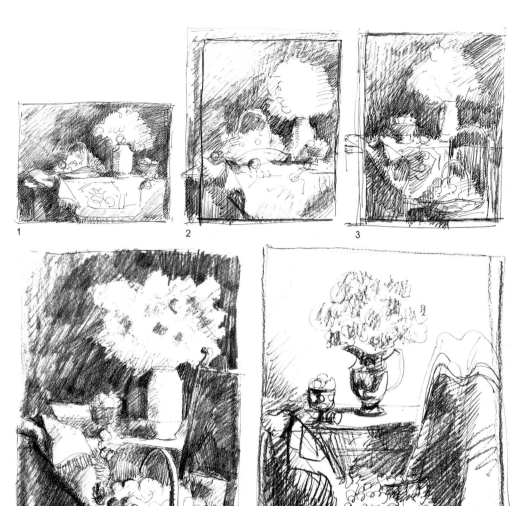

COMPOSITIONAL SKETCHES

1. Using charcoal and ink, I rough in a tabletop composition. I turn the corner of the rug up to create a different shape and texture.

2. Since I like the expanse of rug in the first composition, I try including it in a vertical arrangement.

3. A chair is added to give another level for displaying the fruit.

4. I experiment with the chair on the left side and also move the fold of the rug. But I think that the light striking the chair makes it too important.

5. I crop part of the chair so that it doesn't seem so important. Now I feel the rest of the composition falls into place and looks like a natural arrangement.

6. Here, I make some drastic changes but keep the same composition. I replace the vase with a silver pitcher and drape the chair with a Japanese silk kimono. I try a light background instead of a dark one and I like it better. I replace the basket with a silver tray because I feel it relates better to the opulence of the other objects.

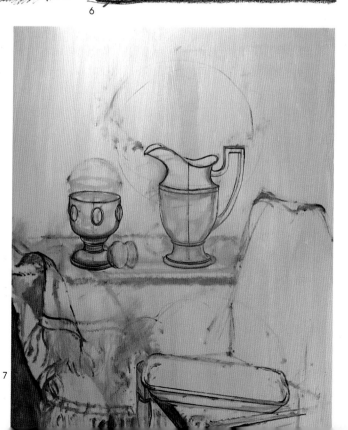

EMBROIDERED SILK

7. The composition is drawn in lightly on Masonite panel with a very thin wash of burnt umber and medium.

8. A flat tone of ultramarine deep is laid in over the dark blue areas of the embroidered silk. I also indicate the blue scroll design.

9. The white area of the silk is in shadow so I paint it gray, using tints of yellow ochre for the highlights.

10. With a mixture of Thalo blue and white, I dab in the embroidery design that shows through from the other side of the silk. I outline the scroll pattern with black.

11. I carefully paint in the intricate pattern, keeping the colors muted in the shadow areas and bright in the light areas. To indicate the thickness of the embroidery, I use very heavy paint for the edges of the highlights.

12. Each small area is rendered to show as much form as possible. Note that the light area is almost all impasto. Once again, a heavy application of paint in this context implies the thickness of the fabric.

13. The rest of the fabric is rendered in the same way. The folds of the blue areas are accented with Thalo blue and black for the shadows and Thalo blue and white for the highlights and light areas.

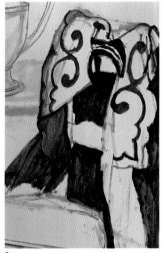

8

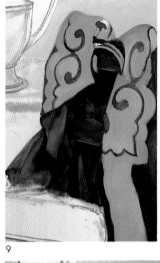

9

10

11

12

13

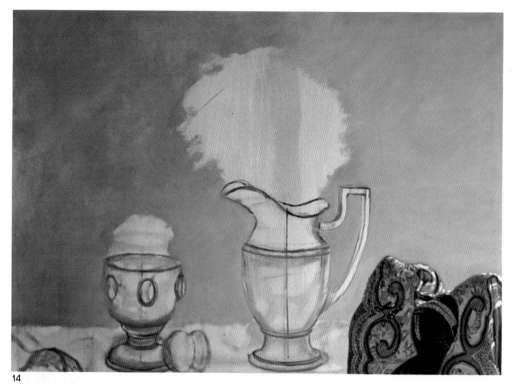

14

ORIENTAL RUG

14. The background is applied very thinly with much of the original ground tone showing through.

15. Using a round bristle brush, I paint in the large patterns in the rug with rough strokes.

16. I finish filling in the large patterns with color and then smooth each area with a large blending brush. I draw in the smaller patterns, then take the blunt edge of the blending brush and stipple over the design. This will soften the effect without actually moving or spreading the paint.

17. In this case, the stippling suggests the soft, thick texture of the rug.

15

16

Shiny metal acts as a mirror, picking up and reflecting nearby colors and shapes.

17

18

19

20

21

SILVER GOBLET AND LIMES

18. I draw in the contours of the limes using a mixture of chrome yellow and black.

19. The interior of the limes is brushed in with a thin application of yellow ochre and a touch of Thalo blue. For the skins, I use a mixture of chrome yellow and Thalo blue.

20. I blend the light and shadow areas, then accent the shadows with black. The rind is applied with thick white paint.

21. Using a small sable, I carefully place the white highlights of the juicy pulp. Then, mixing white with the green skin color, I stipple the highlights to show the skin's texture. An initial coat of burnt umber and black is applied to the goblet, followed by a pattern drawn in with black.

22. The glistening silver reflects everything around it. Using heavy paint, I copy the shapes I see with different colors.

23. I blend the various colored shapes to soften them and then redefine the patterns.

24. With a very heavy impasto, I lay on the white highlights. The highly reflective surface of silver is best suggested with sharp highlights.

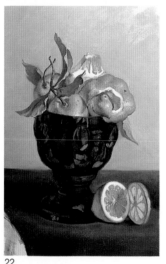

22

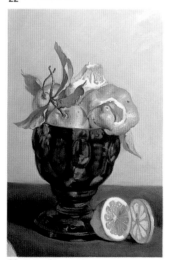

23

24

25

26

27

28

29

When applied
to thick
applications
of paint, a
stippling brush
can suggest
soft, thick
textures.

ORIENTAL RUG PATTERNS

25. Where the rug hangs over the table and shows the coarseness of the weave, I draw in the pattern with lines of paint. A flat tone of red is applied to the fold.

26. As before, the patterned area is stippled to give it a highly textured look, and the tassels are roughed in.

27. With a series of dots and crosshatching the texture of the tassel trim is indicated.

28. The trim is stippled to suggest texture, and then each tassel is defined with light and shadow accents. Note that the tassels going into the shadow area are purposely out of focus.

29. Pattern is drawn in the folded area and then stippled to create texture. On top of the stipple small dots of color are applied with a sable brush.

YELLOW ROSES

30. I lay in a basic gray color tinted with yellow ochre to paint the roses in shadow. To define the petals, I draw into this gray with burnt umber.

31. With a mixture of white and Naples yellow, I brush in the light areas of the roses.

32. The roses are developed by using a subdued yellow gray for the lighter tones in the shadow area and a mixture of yellow ochre and burnt umber for the darker tones.

33. Each petal is blended with the blending brush. Only the petals receiving the light remain strong and are later refined with darks and lights.

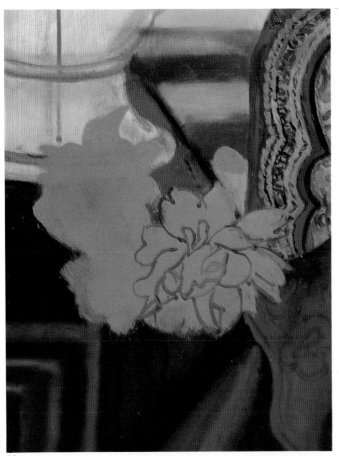

30

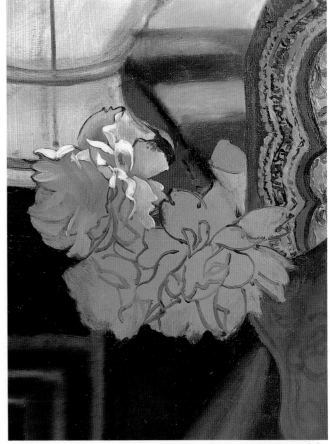

31

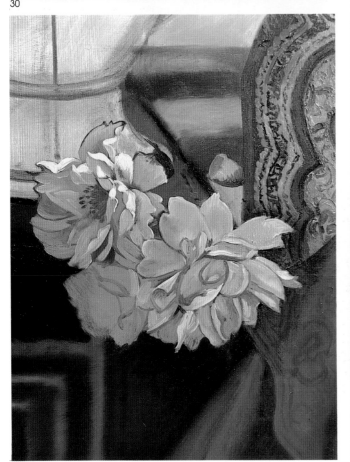

32

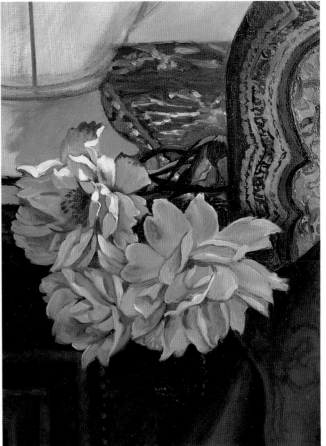

33

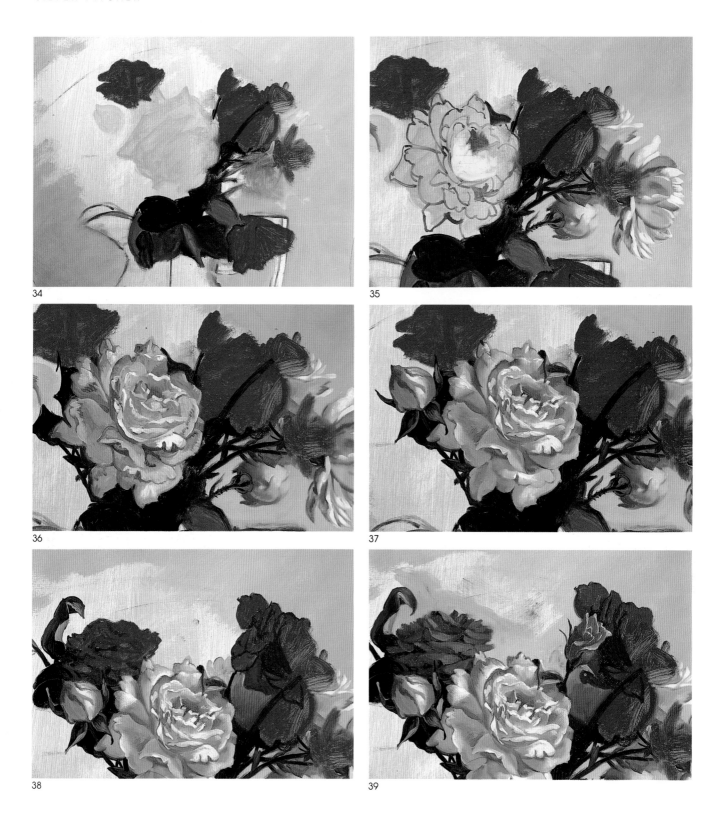

34
35
36
37
38
39

The function of a flower's leaves is often to provide value and color contrast and to set off the flower's forms.

ROSE BOUQUET

34. Flat tones of color are scrubbed in over the gessoed panel for each rose and the leaves.

35. The big yellow rose is defined by thin lines of burnt umber drawn over the basic color. The rose to the left shows the gray shadow used for the color yellow and is softened with the background.

36. The form of each petal is explained with light, shadow, and reflection. Note the reflected tones of pink picked up from the adjacent red roses.

37. Each petal is blended and then the highlights and dark accents are reapplied.

38. I use a mixture of alizarin crimson and black to draw into the flat color of the red roses.

39. Depending on the shade of red, some of the red roses are defined with white hightlights while others are tinged with either yellow or vermilion.

40. To contrast with the flowers and the pale background, the green black leaves are worked along with the roses.

41. The finished bouquet of roses has water drops added. To help give a sense of the depth of the bouquet, I show the backs of the roses as well as the fronts.

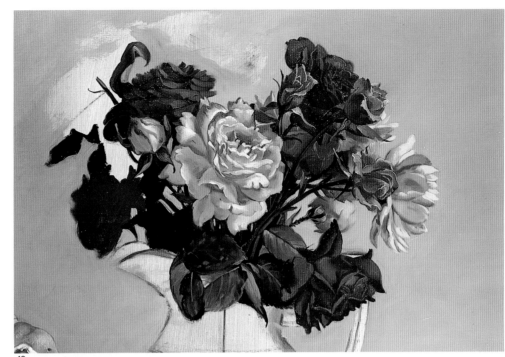

40

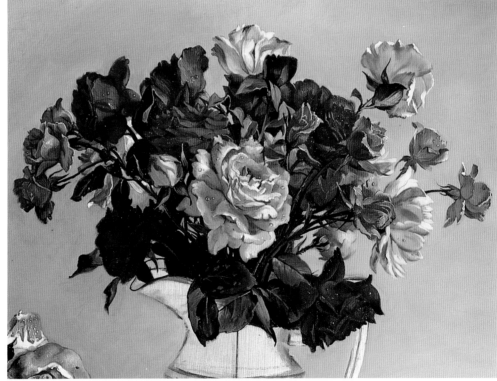

41

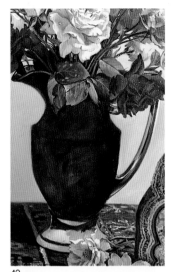

42

43

44

SILVER PITCHER

42. I begin the pitcher the same way I did the goblet, by laying in a flat mixture of burnt umber and black.

43. The pitcher, being smooth, reflects the carpet and the rest of the still life more precisely than the more fragmented, hammered texture of the goblet. Here, I lay in the various colored shapes I see reflected in the metal.

44. The colors are blended, and I redefine the shapes once more.

45. After the colors and reflected scene have been blended and lights and darks restated, I add thick, white highlights to the completed pitcher.

SILVER TRAY

46. I change the angle of the silver tray to make it sit more naturally in relation to the chair. With a mixture of chrome yellow and black, I scrub in a thin coat of color to indicate the green shapes.

47. Each grape is outlined and a bright yellow reflection is painted in. Note that a few grapes are tinted different colors because not all the grapes are green.

48. To indicate a frosty colored skin, a light opaque gray is added to the light area of some of the grapes. Note that this tone is not seen in the shadow areas.

49. For high contrast, cast shadows are kept transparent and small white dots of highlights are added to each grape. The shadows of the plums are laid in with a mixture of black and ultramarine blue.

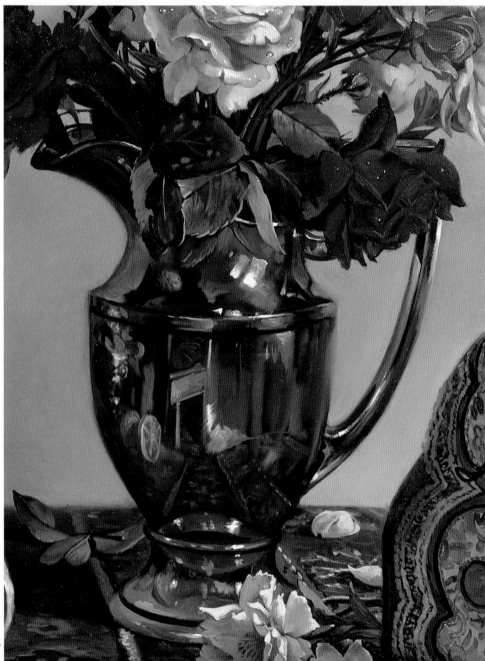

45

46

47

48

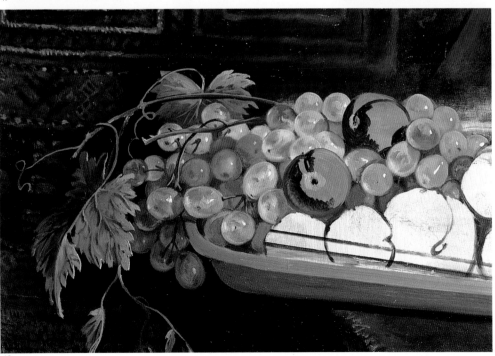

49

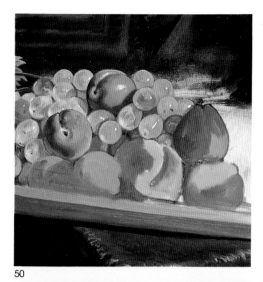

50

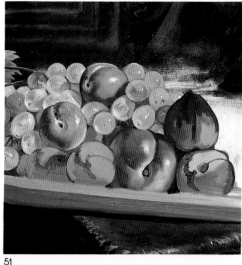

51

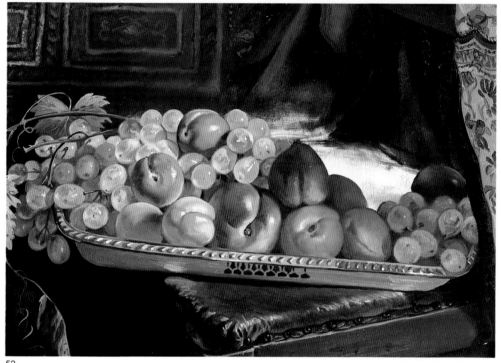

52

A dark glaze applied over a high-key color can subdue it and suggest that it is in shadow.

50. A blue-toned frosting is added to the plums; their highlights are painted in with very soft edges to indicate the more muted, opaque skin. The basic red and yellow tones of the apricots and nectarines are laid in.

51. All shadows, reflections, and highlights are boldly placed.

52. Each piece of fruit is blended and redefined. The fruits on the right are painted in subdued tones to show that they are in shadow. Tints of blue are added to indicate light coming through the blue fabric.

WATERMELON

53. With a mixture of reds and greens the watermelon is blocked in.

54. These colors are then smoothed out with a dry blending brush. Note that the light color at the tip of the watermelon is also in shadow. This presents a problem because this area can easily seem too bright. I will have to correct this later with a darker glaze.

55. I paint in the holes for the seeds and other crevices with pure alizarin crimson.

56. Adding white to the reds I paint in the whitish, watery area of the melon, then stipple it with a bristle brush to get the frosty look. I than add the seeds and tiny white highlights.

57. After the fruit and watermelon are dry, I glaze the area in shadow with a lot of medium, a touch of Prussian blue, and black. Then, to smooth out the colors, I use the blending brush. This dark glaze keeps the watermelon and fruit in shadow. As an afterthought I add the knife, but afterward I decide I don't like it, so I remove it from the painting. I do this by applying a coat of medium to the knife area and simply paint over it.

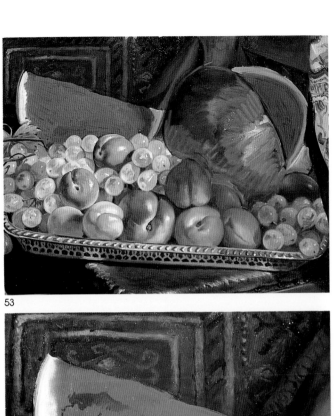

53

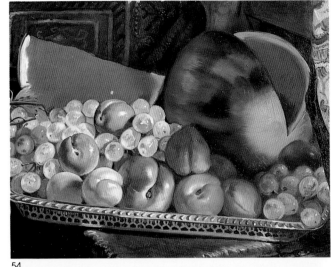

54

55

56

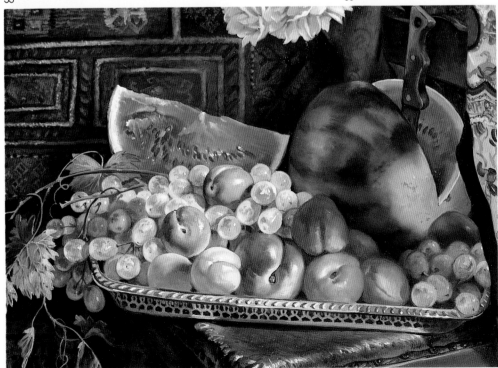

57

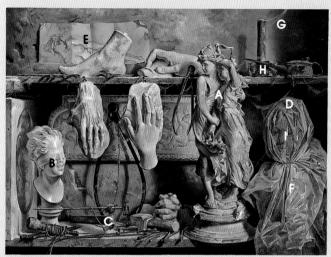

SCULPTOR'S STUDIO, oil on canvas, 43½″ × 31½″ (110.49 × 80.01 cm).

TEXTURES

A. *Plaster of paris*

B. *Marble*

C. *Brass*

D. *Dust*

E. *Paper*

F. *Plastic*

G. *Cobweb*

H. *Cast iron*

I. *Terra-cotta*

1 2 3

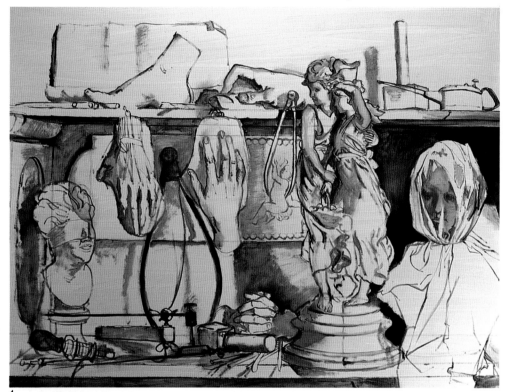

4

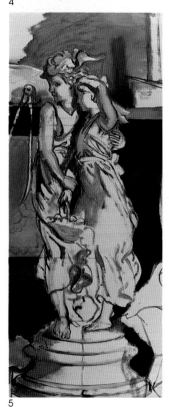

5 6 7

COMPOSITION SKETCHES

I discovered this scene in a sculptor's studio. Since I was unable to paint it on location, I borrowed the objects and re-created the scene in my own studio.

1. The studio walls are covered with shelves full of plaster casts. I decide to show two of these shelves and arrange the plaster casts and sculpting tools on them.

2. I change the position of the hanging hands and place the larger one on the top shelf.

3. I add a marble head on the left to give a contrasting texture (smooth) to the plaster of paris (rough).

PLASTER OF PARIS

4. On prepared canvas, the shelves are measured off and I paint in the objects with burnt umber. First I draw in the outline and then suggest the shadow areas.

5. I lay in the various background values surrounding the plaster cast of the couple.

6. I brush a gray *velatura* tinted with yellow over the burnt umber underpainting, making sure that the edges of the figures are kept soft against the background.

7. Into the gray *velatura,* I redraw the figures with a darker gray tone.

8. Now that I have indicated both the middle tone and darker shadows, I add a lighter gray to the centers of those areas where the light strikes. I continue to develop the plaster cast by adding dark, light, and middle-tone areas and then blending the tones.

9. I then come back and reestablish the light and dark accents.

10. With yellow ochre and burnt sienna, I brush in the discoloration caused by the metal armature inside the cast.

11. When the statue is finished I add a few more stains and details. Note that there are no pure white highlights on plaster.

8

9

10

11

12

13

14

15

16

17

TERRA-COTTA AND PLASTIC

12. I cover the terra-cotta head with a mixture of burnt sienna and yellow ochre. The plastic wrap is painted in flat gray tones.

13. With a mix of burnt umber and black, I draw in the shapes of the eyes, nose, and mouth. I brush yellow ochre and white into the original mixture to show highlight areas.

14. Using a dry blending brush, I soften and refine the features of the face.

15. The different shapes of the plastic folds are rendered using black and white with a touch of Prussian blue.

16. Various tones of blue-gray are used to paint in the folds. I mix yellow ochre, burnt umber, and white to indicate the dust on the inside of the transparent plastic.

17. Once I apply the dust color, I softly stipple it in to lose any sharp edges. Heavy impasto white tinted with Thalo blue or alizarin crimson is added for the highlights. These colorful highlights are the result of a kind of rainbow iridescence that plastic sheeting gives off in the light.

18. The rest of the plastic is painted using the same procedure, and the cast shadows on the plaster of paris figures are glazed blue. They are blue because the color cast off by the plastic is basically blue.

Pure white is the brightest light that a painter has on his palette. It must be reserved for the most light-reflective object in the painting.

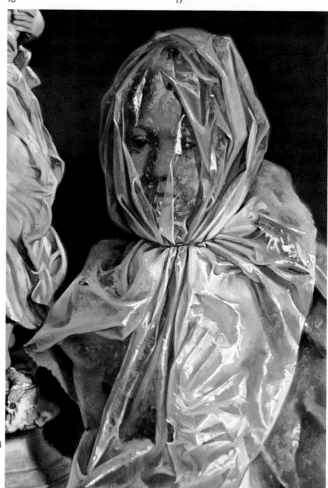
18

COBWEB

19. Using mostly medium and a touch of gray, I brush in a cobweb shape. In this case, very little color is needed; the gauzy effect is achieved primarily by spreading the gray paint very thinly with the blending brush.

MARBLE

20. I fill in the background areas and apply a middle-tone *velatura* to create the light and shadow areas of the marble bust. I tint the light areas with blue, the shadow areas with a blue-gray mixture.

21. Light and shadow areas are lightly blended with a blending brush. Note that this initial layer of paint is so thin you can see the features that were drawn in the underpainting.

22. Following the same procedure as I did for the plaster cast, I remark the marble head with stronger shadows.

23. I blend and reblend and then start adding my lights. Even though the marble appears white it has to be rendered dark enough to show contrast when the highlight is applied. These highlights are refined and tinted with color. Since marble is perhaps the most reflective texture in this painting, the highlights are heavy and very white; they are lightly blended but not on all sides, the way a less reflective texture would be.

19

20

21

22

23

24

25

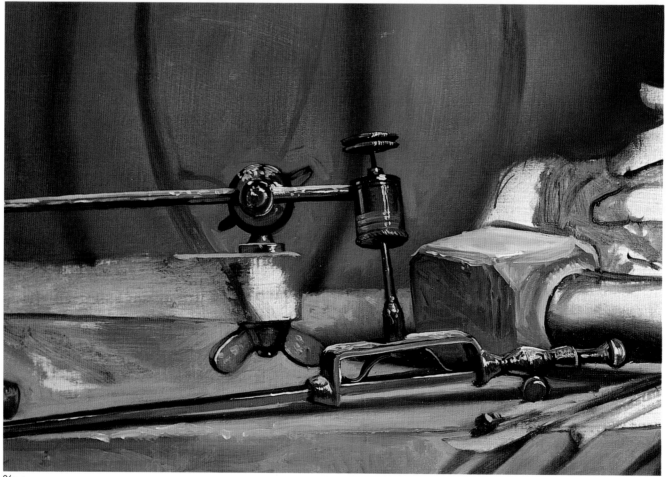

26

A three-dimensional form is developed by dividing
it into two major areas: light and shadow.

METAL TOOLS
AND BRASS

24. For this brass measuring device, I use black for the shadows and a mixture of yellow ochre and burnt sienna for the light areas.

25. Into the middle tone, I draw with yellow ochre and define details with black.

26. Naples yellow is used for the brass highlights. Other areas are covered with marble dust and painted light gray.

27. Chisels and rasps are painted in first with a solid color; then dark browns and highlights are indicated. The soft cast shadows of these tools give them the appearance of projecting over the shelf.

28. The hand drill is painted in first with solid color, and the stippled gray dust helps to explain the forms. Note that the small brass parts of the drill catch the Naples yellow highlight.

29. The rest of the bottom shelf is painted in indicating shadow areas and light areas.

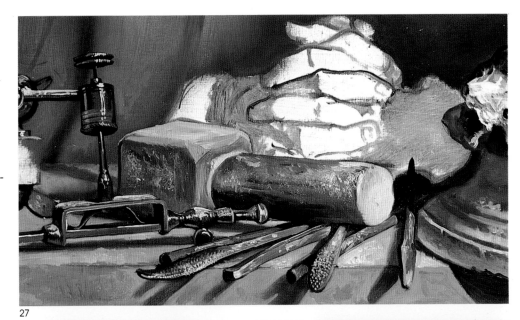

27

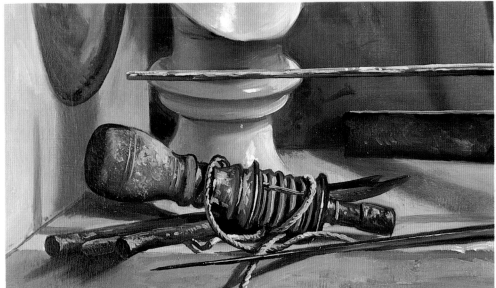

28

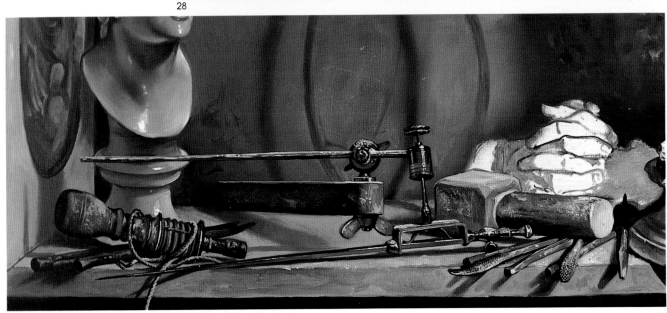

29

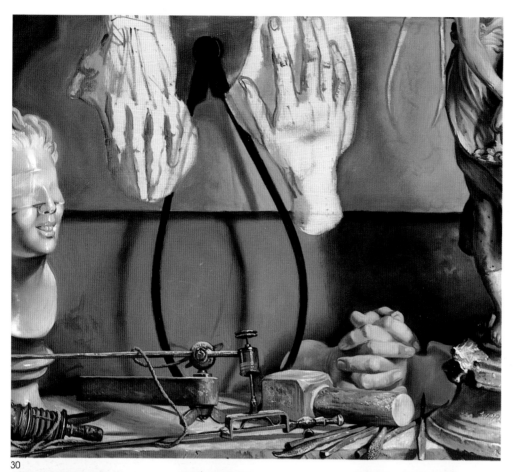

30

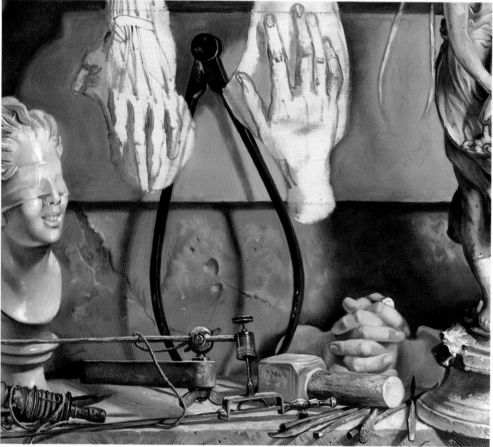

31

PLASTER BAS-RELIEF AND PLASTER HANDS

30. I paint the plaster bas-relief a deep gray tone to keep it in half shadow. The wall under the relief is laid in with burnt umber, and the cast shadow from the calipers is blended to keep its edges diffused. The cast shadow from the bas-relief is kept sharp next to the edge of the relief and is softer as it blends into the wall. The calipers are painted solid black.

31. Cracks and holes are painted into the wall and then stippled to keep them slightly out of focus. This keeps the wall in the background and the objects rendered in the foreground sharper and more defined.

32. I paint tones of gray into the black wet calipers to define their shape. The plaster hand is rendered using the same procedure as was used to paint the plaster couple: a coating of *velatura* is applied, details are drawn in with darks and middle tones, lighter tones are added, everything is blended, and finally light and dark accents are reestablished.

33. I draw in the forms of the anatomical hand with a mixture of burnt umber and black. Cracks, marble dust, and blemishes are added to the plaster hand.

34. I add a touch of yellow ochre to the dominant gray and paint in the light areas of the anatomical hand. I blend the light and dark tones together and then redefine dark and light accents.

35. The hand is blended once again and then restated with shadow and light. Note that the highlight is not white; it is comparatively dull and tinted with yellow because the hand is covered with marble dust. Compare the highlight of the hand with the highlight on the marble head.

36. I lay a thin coat of medium over the entire dry bas-

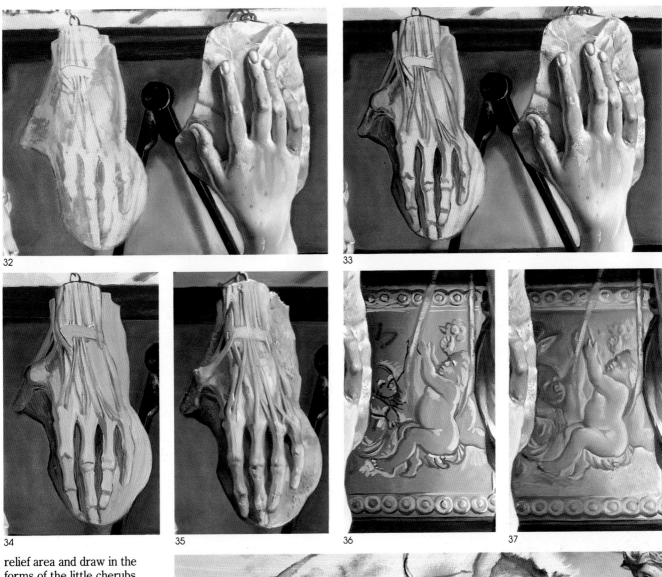

32

33

34

35

36

37

relief area and draw in the forms of the little cherubs with two colors: dark for the shadow, light for the highlights, leaving the dry base coat as the middle tone.

37. I blend the figures of the cherubs with a blending brush, their edges should remain very soft since the bas-relief is in the background.

38. In this detail of the finished section of the painting, the remainder of the bas-relief is rendered keeping the light tones that are in shadow darker than those light tones in the light area. Note the three-dimensional effect created by the cast shadows and the in-and-out-of-focus painting.

38

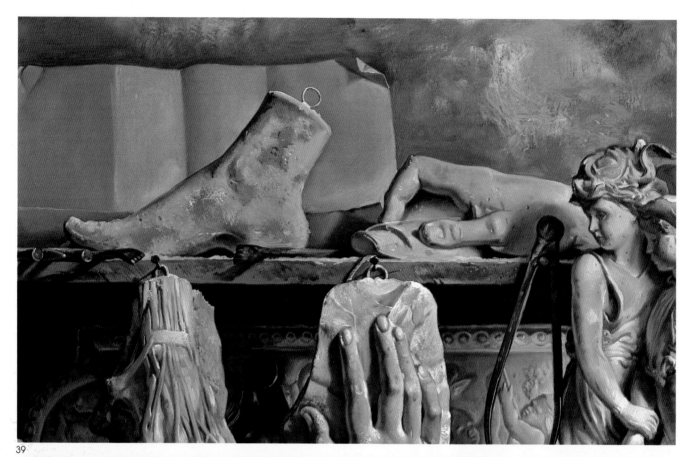

39

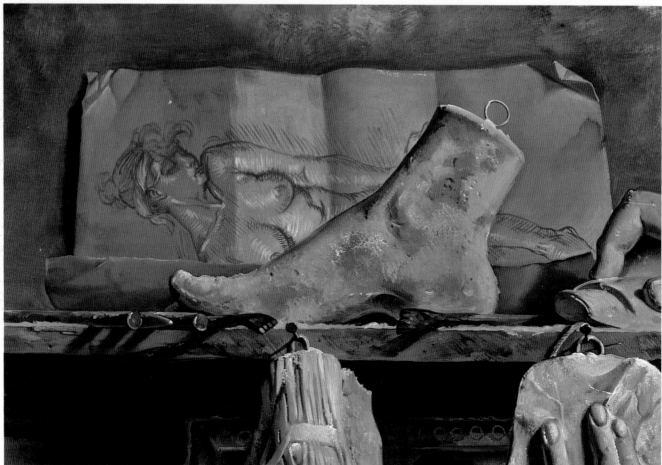

40

PLASTER FOOT AND HAND

39. The plaster foot and hand are rendered in the same manner as were the other plaster casts. After all the values of gray are laid in and blended I add a touch of yellow to the foot cast and a touch of blue to the hand. I then blend again. Using a large bristle brush, I lay in the pink paper flat with a mixture of burnt sienna and white. A small sable is needed to indicate the corners and the small cast shadows and shadow areas.

40. Once the paper is dry, I put a thin coat of medium over it and draw in the figure with a darker mixture of burnt sienna and white than was used for the paper. Note that the drawing follows the contours of the folds in the paper.

CAST IRON HAMMER AND METAL OIL CAN

41. With the background wet, I rough in the shadow area around the hammer with a mixture of yellow ochre, black and white, and burnt sienna. This is then lightly blended and stippled to create a mottled effect.

42. I blend the background area with a large blending brush and lay in the base colors of each object, keeping their edges soft against the background.

43. With small brushes, I add the textural details to the hammer and oil can, such as dents, marble dust, and the colors of rust and grease. I then take medium and add a touch of gray to paint in the cobwebs.

41

42

43

The dull, mottled texture of plaster is characterized by diffused, gray-toned highlights.

PAINTER'S STUDIO, oil on canvas, 43½" × 31½" (110.49 × 80.01 cm).

TEXTURES

A. *Glass jars*

B. *Tin coffee cans*

C. *Plastic containers*

D. *Paper toweling*

E. *Marble tabletop*

F. *Paintbrushes*

G. *Wooden palette*

H. *Cotton shirt*

I. *Fleshtones*

J. *Clay mortar and pestle*

1

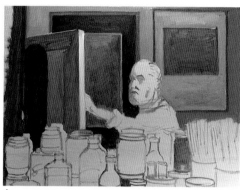

2

3

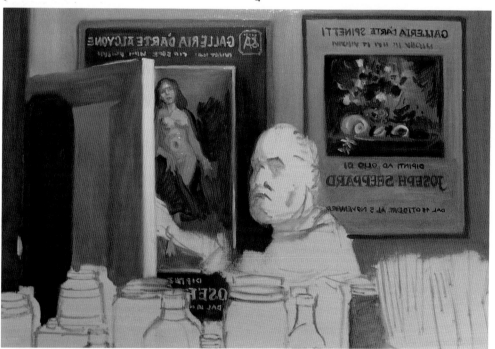

4

5

6

7

COMPOSITION SKETCHES

This painting was inspired by *Sculptor's Studio*. I decided to use the marble-top chest where I grind my pigments for a subject because it is filled with all kinds of interesting objects and textures.

1. The marble-top grinding table in my studio looks much like this but I feel it's too cluttered and too confusing as a basis for a painting. In the background is a bulletin board for notes and drawings.

2. In this sketch, the point of view is raised so that more of the top of the chest can be seen. I also rearrange the bottles and jars to make them less confusing. The paper towel roll is placed to break the strong horizontal line caused by the marble top. It also rounds out the corner of the composition. I place a mirror in the background instead of the bulletin board; this opens up the composition and gives more depth to the painting.

THE UNDERPAINTING

3. The composition is drawn in on canvas using burnt umber.

4. With flat tones of neutral colors, I fill in the areas for the canvas, posters, and wall reflected in the mirror.

5. The pictures on the posters are roughed in and the lettering is painted in reverse. I show the light coming through the canvas by painting a mixture of yellow ochre and cadmium red. This color gives the impression of brightness and transparency because it is placed in a shaded area.

6. On the edge of the painting I dot in the tacks with a small brush and lay in the folds of the canvas with darker paint. The reproductions on the posters are first blended with a blending brush, then stippled to soften the image. I paint the wall behind the mirror and make the cast shadow darker and sharper nearest the mirror and more diffused as it blends into the wall.

8

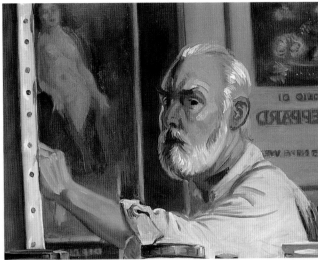

9

7. With mixtures of black and white, I paint in the tops of jars and their reflected images in the mirror as well as the tops of the brushes and their reflections. Note that this is a complex painting because it is composed of four different planes. Starting from the foreground these are: the open drawer of the table; the palette and mortar; the rows of jars, brushes, and bottles; and the mirror. The mirror creates an additional plane with the self-portrait and an even deeper one with the re-flected posters and wall. Each plane must be distinct from the others so that each object remains in its proper place.

COTTON SHIRT AND FLESHTONES

8. Middle tones are laid in for the shirt and self-portrait. Note that in the fleshtones wherever a transaction from light area to shadow occurs, the color changes from a fleshtone to a gray.

9. Into these wet colors, I draw with darker and lighter colors describing the forms.

10. I refine the modeling by blending and restating lights and darks in the self-portrait. I then brush in thin *velaturas* of gray over parts of the mir-ror to suggest a plane in front of the mirror image.

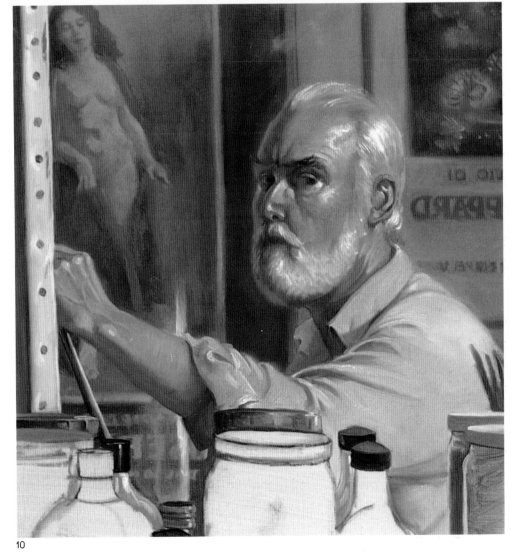

10

A pale color placed in a shadow area
suggests the presence of light.

11

12

13

14

15

16

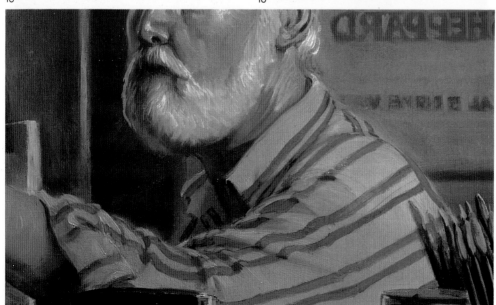

17

PAINTBRUSHES

11. Flat, thin colors are laid down for the brushes and a glaze of black is scrubbed over the background to increase the depth of the shadow.

12. I blend the background with a blending brush and outline the brushes with black paint to indicate the shadow areas.

13. I vary the colors of the brushes with mixtures of burnt sienna, yellow ochre, grays, browns, reds, and white. Note that none of them is a pure color. The tips of the brushes are defined with light areas and a line of shadow. I then lay in a dark gray for the metal ferrules.

14. Dots of highlights are added to the ferrules to suggest the shiny quality of metal. Because they are closer to the foreground, the brushes in front are more defined whereas the brushes in back are left more muted. I scrub in a deep gray for the tin cans.

TIN COFFEE CANS

15. The texture of tin is developed very similarly to that of silver, although it is slightly more muted. I begin with a dark, middle-tone, and draw back into it with black paint for the rings of the can. At this stage, I try to render the can in as low a key as possible, so the highlights can be saved for last.

16. To the dark, middle-tone gray, I add lighter gray reflections. Then heavy impasto highlights are added, which suggest the texture of metal.

COTTON SHIRT

17. Over a thin coat of medium, I add blue stripes to the shirt. The stripe follows the forms of the shirt's folds; dark accents are added wherever the stripe crosses a shadow.

WOODEN PALETTE

18. I render the wooden palette by looking down at the one I'm holding in my hand. I first lay in the wood color of burnt sienna and yellow ochre mixed with white. Then each color from my actual palette is duplicated for the painted palette. Cast shadows and white highlights are added to the various globs of paint to create a three-dimensional effect.

PAPER TOWELING, METAL PAINT TUBES, AND CLOTH

19. The paper towel roll, tubes of paint, and cloth are all created with variations of gray, black, and white.

20. As I begin to render the shadows and lights on the paper towel, paint tubes, and cloth, their textures become more apparent. Note that the paper towel and cloth have soft transitions from light to dark, but for the shiny metal tube the transition is more abrupt.

21. Here, I apply highlights to different subjects: The highlights on the cloth have soft edges; those on the paper are even more diffused; and those on the paint tubes are sharp and heavy. Thus, in general, the harder the object the more hard-edged and visible it is.

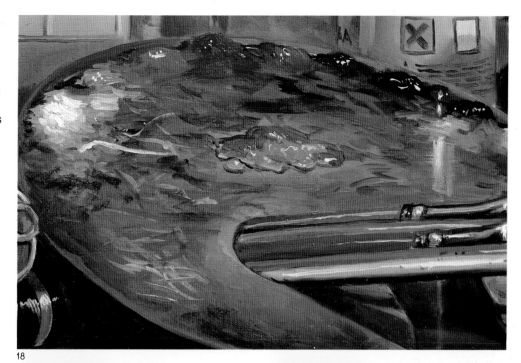

18

19

20

21

22

23

CLAY MORTAR AND PESTLE

22. To the outside and edge of the mortar and pestle, I lay in a mixture of black and white. The inside is painted with alizarin crimson mixed with medium, and black is added for the shadow areas. Later, when this area is dry, I will glaze the inside with pure alizarin crimson to make it more brilliant.

23. The jars of powdered pigment are rendered very similarly to the jars of condiments in *Garden Vegetables* (pages 72–73, steps 30–37). Of course, in this case, the pigment inside the jars is rendered more simply.

PLASTIC AND GLASS JARS

24. Here we have opaque plastic jars, transparent glass jars filled with powder pigments, and transparent glass bottles filled with turpentine, varnish, or oil. I begin all the jars in same way: I lay in a thin middle tone of each color, using no. 6 brushes and making sure that all of the canvas is covered.

25. Using smaller brushes, I start to define each object with details of line and color. I draw in the tops of the jars.

26 I pick out the shadows and reflections on the plastic containers and reflections on the tin can and add texture to the jar tops. I put white highlights on the shiny plastic bottle caps. These highlights tend to be very pure and white because plastic bottle caps are hard and shiny, whereas the plastic jars in this painting have a film and density to their texture that make their highlights more muted.

27. I paint a strong reflection on the bottle of oil to indicate light coming through the liquid; it is a bright yellow in an area that is normally in shadow, which makes the color pop out. The top of the bottle is painted with an opaque gray to suggest a layer of dust. The paper label is rendered complete with its wrinkled fold and then the lettering is applied. A blackish dusty tone and pure vermilion color are painted in on the powdered pigment jar.

28. After the label is painted and drawn in on the plastic container, I indicate the dried gesso that has been spilled over the sides. This paint conveys a thickness that is exaggerated by adding a cast shadow. The transparency of the varnish bottle is suggested by showing the red of the jar behind it.

24

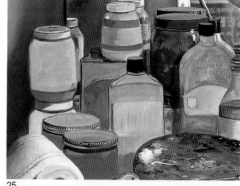

25

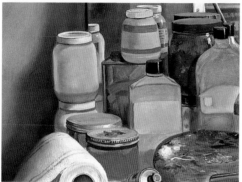

26

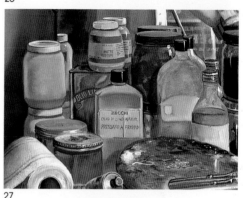

27

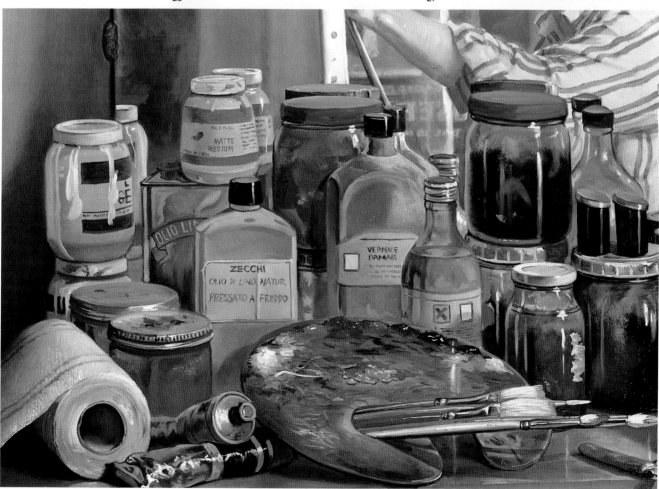

28

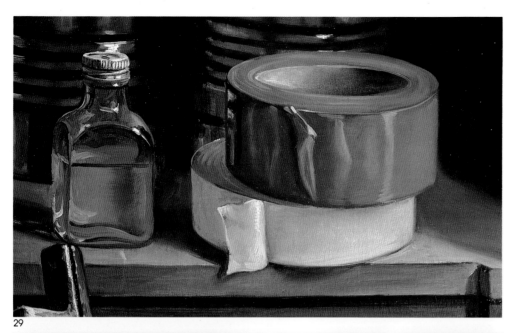

29

30

31

PLASTIC AND MASKING TAPE

29. The distinction between these two different kinds of tape is made evident by the application of highlight and reflective surfaces. Because masking tape has a dull, coarse texture, it has no highlight. However, the tape on top is plastic, so its glossy texture shows a definite highlight. Note that the cast shadow from the small bottle of oil next to the tape catches some of the brilliant yellow from the light passing through the bottle.

MARBLE TABLETOP

30. A thin coat of medium is applied over the marble tabletop. With a small sable brush and light gray paint, I duplicate the marble pattern.
31. With a light touch of the blending brush, I soften the edges of the marble grain, being careful not to lose the pattern in the process.

DRAWING PAPER AND CONTÉ DRAWING

32. I paint in the middle tones of the paper and the darker tape. I also add the cast shadow and shadow areas and blend everything with a blending brush.
33. I refine the folds in the paper and render the highlights and cast shadows of the piece of tape.
34. After the paper is dry I put a coat of medium over it and paint the drawing on the paper. I do this with a small sable brush dipped in burnt umber.
35. An afterthought that helps the composition and also determines the plane of the mirror is a photograph of my wife, Nina. At first the photograph was rendered sharply, but because it is meant to be kept at the distant plane of the mirror, I needed to soften the image with a blending brush. The absence of sharp-edged darks helps to keep it a background object.

32

33

34

Once the basic form of an object is modeled and the paint is dry, patterned textures, such as wood grain or the veins in marble, should be drawn in with small sable brushes.

35

36

THE BROKEN EGG

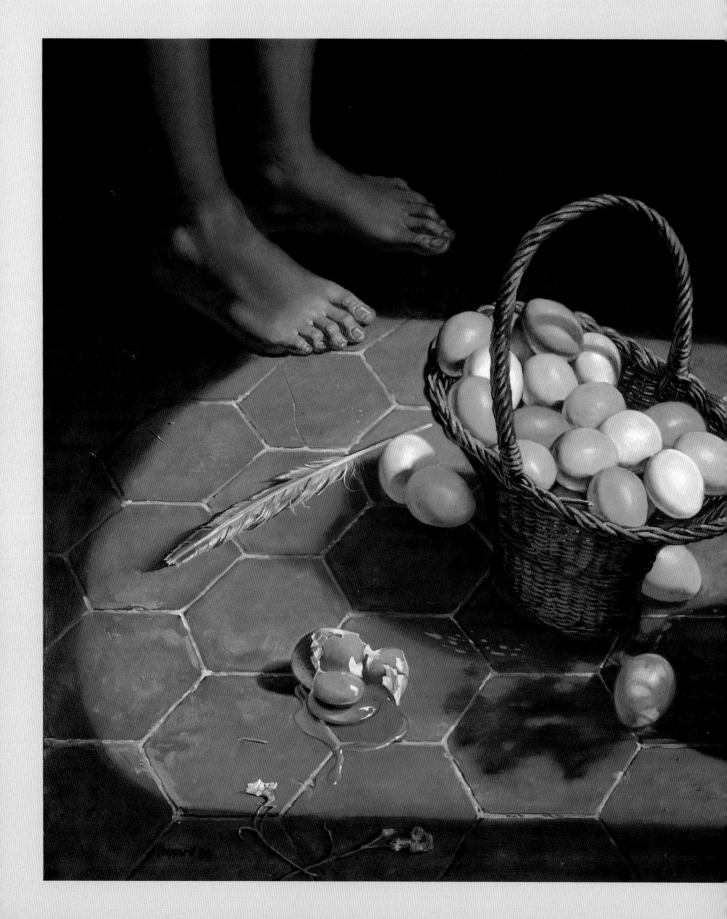

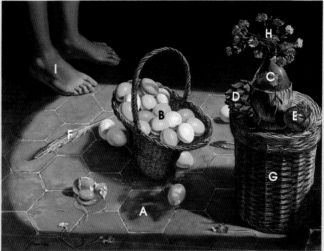

THE BROKEN EGG, oil on panel, 35½" × 27" (35" × 27") (90.17 × 68.58 cm).

TEXTURES

A. *Floor tiles*

B. *Eggs*

C. *Glass wine bottle*

D. *Artichoke*

E. *Red onion*

F. *Feathers*

G. *Wicker baskets*

H. *Flowers*

I. *Feet*

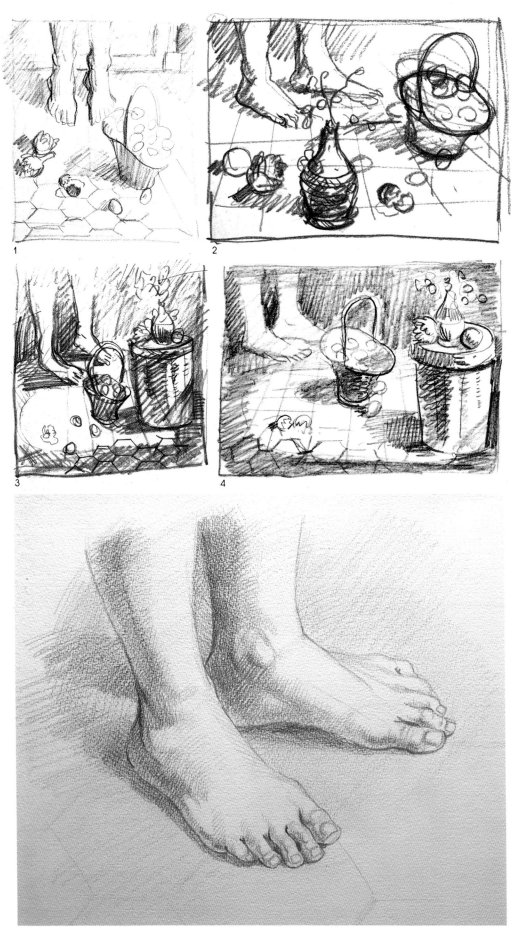

COMPOSITION SKETCHES

1. I arrange the composition looking down at the floor. I want to show the presence of a human, so I draw feet in the background. I add three eggs and two artichokes to the floor.

2. I change the composition to make it work horizontally. A broken Chianti bottle filled with small flowers is added and the feet are placed away from the center. I don't like this composition, but I feel that the move away from the first idea is good and that the composition is going in the right direction.

3. This sketch was inspired by the sun coming in my window late in the afternoon. All of a sudden I could see the possibilities for the still life to become very dramatic. I raise the wine bottle by putting it on top of a basket. The lit flowers against the background pull the composition together and make it work.

4. The final composition is worked out with all the objects, shadows, and spaces in place.

5. Here, I used a model, so that I would have a finished study for the feet in the painting.

THE UNDERPAINTING

6. I take a red colored pencil and rule off perspective lines and draw in the hexagon tiles.

7. The various objects are drawn in with burnt umber diluted with medium. I then indicate the cast shadows on the basket and floor, keeping the tone transparent.

When a painting
includes
geometric forms,
the composition
should be
worked out
beforehand with
perspective lines.

6

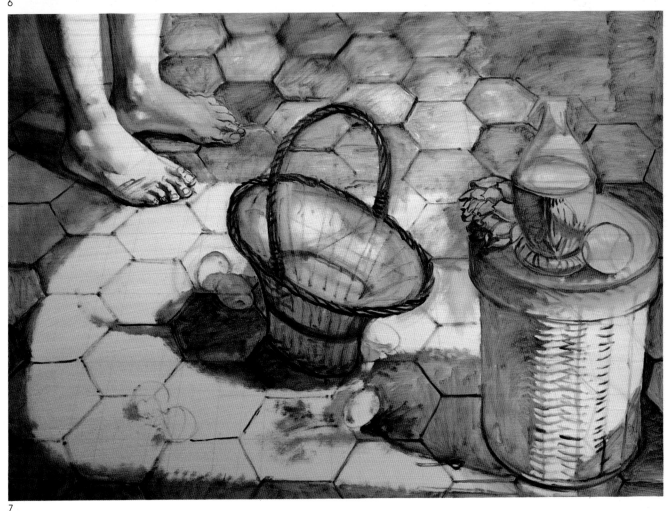

7

8

9

EGGS AND BASKET WEAVE

8. I paint in the light area of the eggs varying their colors but keeping them basically in the earth tone range. Then I brush in the shadow and cast shadow of each egg with a dark black-and-white gray. Note that the degree of brightness and light on each egg is dependent on adjacent objects.

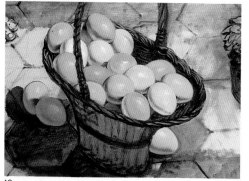

10

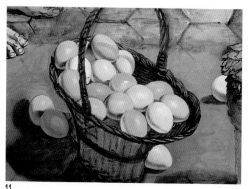

11

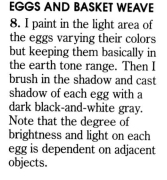

12

9. The area between light and shadow on the eggs is blended smooth with a small, soft bristle brush.

10. I repeat the blending process, then restate the darks and lights by making the shadows darker and adding highlights to each egg.

11. Eggs are subtly colored and thus can be difficult to render because basically you only have form to work with. Here, a cast shadow from the basket handle is drawn over a few of the eggs. I make sure these cast shadows follow the rounded shapes of the eggs. Thinned color is applied to the floor in order to keep a soft edge between the eggs and background.

12. I start to draw in the weave of the basket with burnt umber and black.

13. With a mixture of yellow ochre and white, I paint in the lights of the straw lip on the basket. There is a strong vermilion reflection from the floor onto the basket, which I brush into the wet underpainting.

13

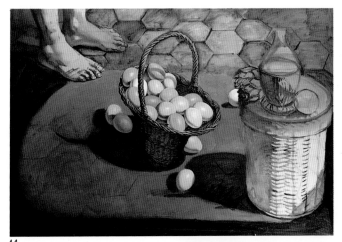

14

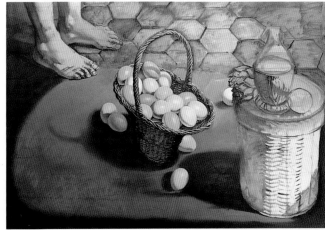

15

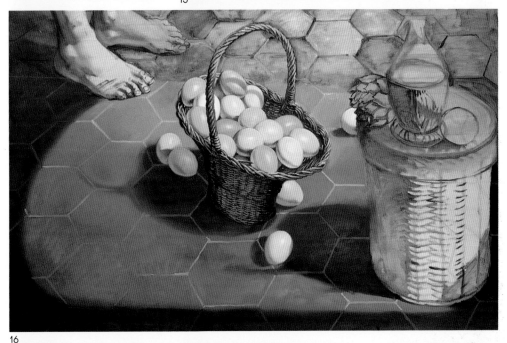

16

14. The handle of the basket is painted with lights and darks. On the floor I scrub in color keeping the foreground area rich in color and the background grayed and softened to create a sense of depth. I do the same with the cast shadows of the baskets: The part of the shadow closest is darker and sharper; the part farther away is lighter and more diffused.

FLOOR TILES

15. The floor is smoothed with a blending brush. Note that the paint is still thin enough to see through to the shapes of the tiles.

16. With a light gray impasto, I paint in the cement between the tiles, making the gray darker where the seams go into shadow. The space on the left side of the floor is purposely left undeveloped because I plan to paint in the broken egg there and I don't want heavy paint under it.

17. I take a small sable brush and paint in the shadows from each tile on the shadow side. Then with a variety of gray tones, I scrub thin *velaturas* (medium plus opaque paint) over each tile to give each one its own texture. The *velaturas* also serve to tie the different colors of the tiles together and make the floor one unit.

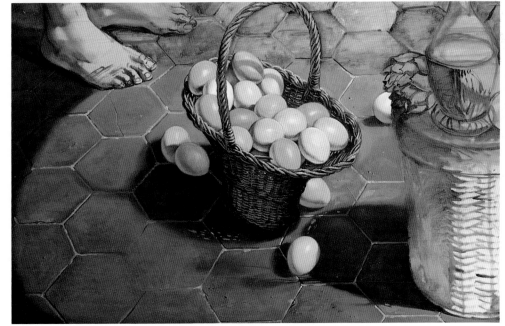

17

BROKEN EGG

18. Over the dry tile floor I lay in a thin coat of medium, then begin to draw in the shell and paint in the yoke with chrome yellow. The albumen, or white of the egg, is painted with medium tinted with black and has a small cast shadow.

19. The yoke is rendered and blended with a blending brush. Then over the albumen, I paint in the cement underneath and also the reflective light on the left side. I blend both these, then add pure white highlights. The egg white is painted using the same technique as used for the water drops in *Spring*

Flowers (see pages 52–53, steps 7–11). The object that the albumen sits on gives it its color, just as the flower gave the water drop its color.

20. I paint in the colors of the broken eggshell working some background against it to keep the edges soft. Inside the shell I add color to the

shadow to show light coming through the shell.

21. Here, the cracked edges of the shell are kept sharp to show how thin and ragged the eggshell is. Note that the inside membrane of the eggshell is made visible here.

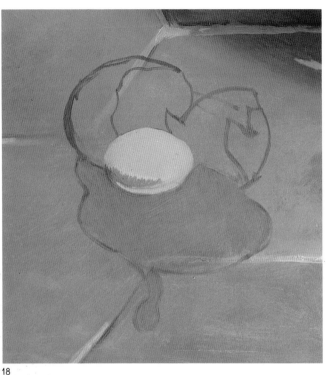

18

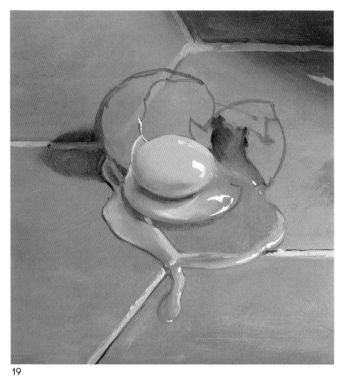

19

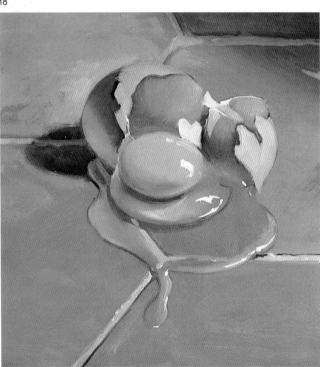

20

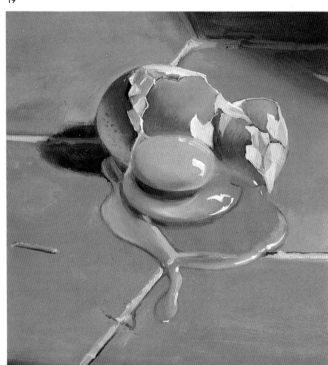

21

FLOOR TILES

22. The dark area of the floor is scrubbed in with a large bristle brush. The middle-ground area is a transparent mixture of black and burnt umber. For the background area farthest back, I add white and Prussian blue to this black-burnt umber mixture, so that it is more opaque and lighter in tone.

23. I take a large blending brush and smooth out the shadow on the floor. When I finish, the blending brush has become dirty with paint and medium. I take what is left on the brush and scrub in the wine bottle shape.

FEET

24. I cover the light section of the legs and feet with gray and use a darker gray for the shadow area. Note that an even lighter tone is used for the toes that protrude out into the light. The shadow accent is painted in burnt umber and the reflective light is a mixture of vermilion and gray.

25. I blend and model these tones together with a blending brush, one correcting the other, until the forms of the legs and feet seem right to me.

26. Into the light area I add tones of yellow ochre, white, and vermilion. These are modeled into the toe forms, and then highlights of yellow ochre and white are added. Burnt umber is used to draw in the shadow accents.

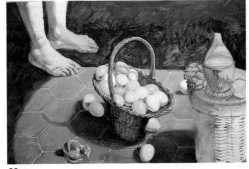

22

23

24

25

26

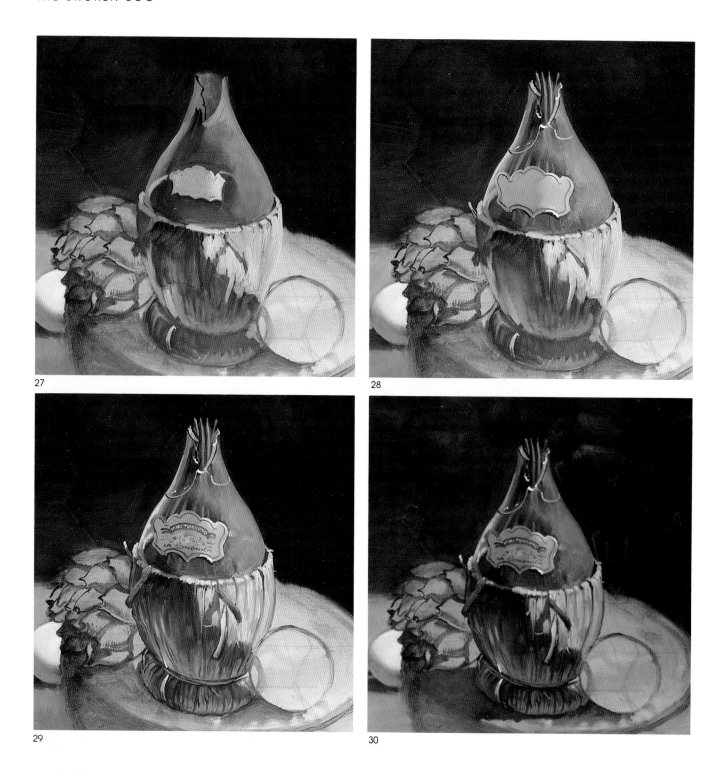

27

28

29

30

A *velatura* is a translucent coat of paint
that allows the dry undercoat to show through. It is
especially useful in areas that need to be unified
and enriched with a common color and value.

GLASS WINE BOTTLE

27. I paint in the bottle with a thin green mixed from chrome yellow, black, and a blue. The dark shape on the left of the bottle will be a cast shadow from the flowers. On the right I paint in gray dust that only shows on the light side. I start to draw in the label. With thick strokes, I mark in light and shadow on the straw part of the bottle.

28. Here, I indicate light and shadow on the label. The thick, jagged edges of the broken glass are brushed in with green paint. Over the green, shadow areas are drawn in with black lines of paint and small impasto highlights with white and yellow. I also draw in the flower stems. The straw part of the bottle is blended with a blending brush.

29. I increase the light coming through the bottle on the shadow side, on both the glass and the straw. The letters on the label are drawn in and the small details of straw rendered.

BACKGROUND

30. I decide to create more atmosphere and put a *velatura* of gray on the background surrounding the bottle. After it is scrubbed in, with lots of medium, it is blended, creating a foglike effect.

WICKER BASKET

31. I rough in the large basket with light and dark and put a coat of alizarin crimson on the onion.

32. Into the basic coats of color on the basket, I start to draw in the weave.

33. Using the Naples yellow I carefully paint in the lights on the basket rim where the sun strikes.

34. I finish the basket weave by painting in the vermilion reflection from the floor.

31

32

33

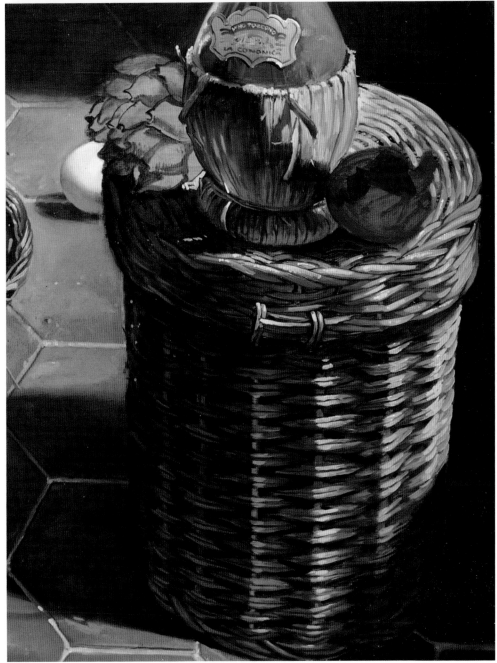

34

35

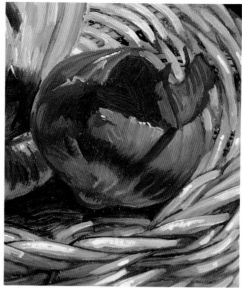

36

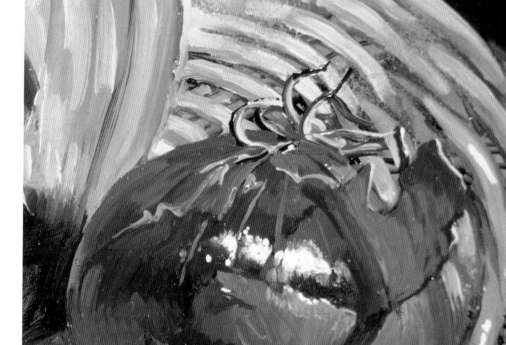

37

RED ONION

35. I begin the onion by painting in the dark area with alizarin crimson and black mixed. I copy the various local colors I see on the onion. The shadow area is black; the reflection from the straw is a mixture of yellow ochre and vermilion. White is added to alizarin crimson to fill in the light areas.

36. The onion is rendered by showing the differences between the transparent skin against the light, the outside crinkled skin, and the inner dark layer of skin.

37. The onion roots are added, and, to show its shiny skin, a heavy impasto highlight is brushed on the onion.

SMALL FLOWERS

38. A flat tone of pink mixed from alizarin crimson and white is painted in the different shapes of each flower.

39. Over the wet pink tone, I draw pure alizarin crimson to show the shadow areas of the flowers. Then, with white, I indicate where the light hits each flower. Some pink-toned reflections from the floor are painted in with vermilion mixed with white. Note that the vermilion reflections are warmer, whereas the alizarin crimson reflections have a cooler tone.

40. The flowers and stems are finished. They are made to contrast with the background: Where the flowers are light the background is dark and where the flowers are dark the background is light.

38

39

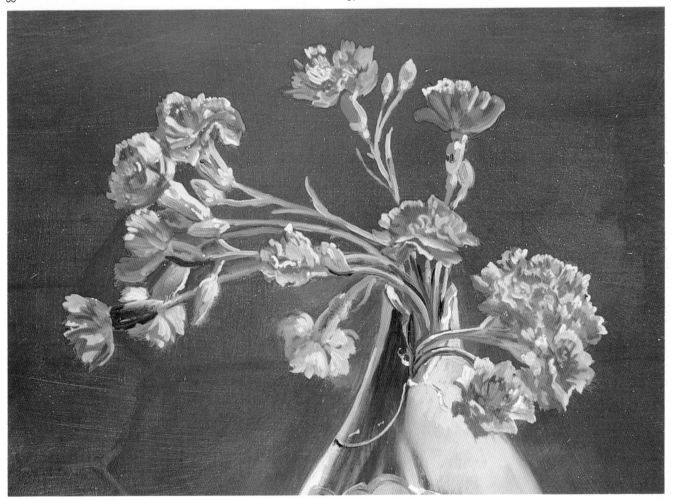

40

Flowers can be developed with three values
of one color combined with white: undiluted color
for the shadow areas; color mixed with white for
the middletone; and white for the light areas.

41

42

43

44

ARTICHOKE

41. A coat of alizarin crimson mixed with ultramarine blue is brushed in thinly over the filled-in outline of the artichoke.

42. I mix a green using chrome yellow and Prussian blue and paint in the tips of the artichoke leaves.

43. Adding white to the alizarin crimson and ultramarine blue mixture, I lay in the lower part of the artichoke leaves with a purple tone. I blend the purple and green tones together with a blending brush. Then, with alizarin crimson and black, I redraw the shadows between the leaves.

44. Reflections from the warm-colored terra-cotta floor are painted in with vermilion. To the center of the leaves facing the light, I add a white highlight.

COLOR ADJUSTMENTS

45. At this stage, it seems to me that the painting is becoming too monotoned—too red—so I add some white flowers to the arrangement. Note that their faces are turned away from the front, a feature that adds depth to a picture.

46. The flowers create cast shadows on the floor, so I sketch them in loosely. The edges of the cast shadow must be kept soft because if they are too sharp, they become objects instead of shadows. Note that the shadow follows the form of the egg.

47. Here, I change the colors of some of the eggs to white in order to get rid of the red cast of the overall painting.

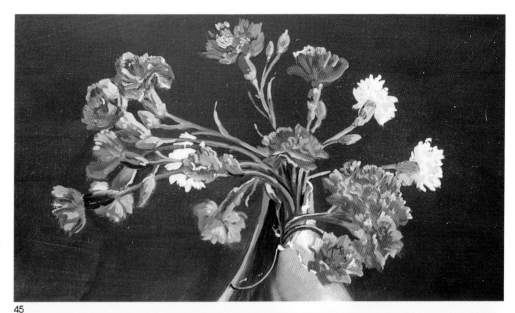

45

46

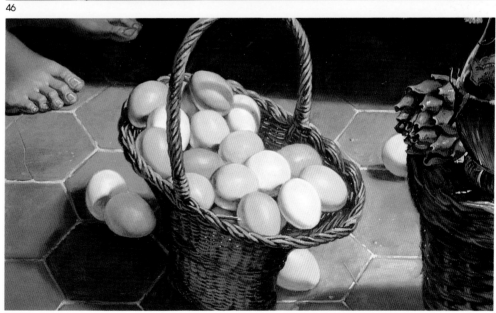

47

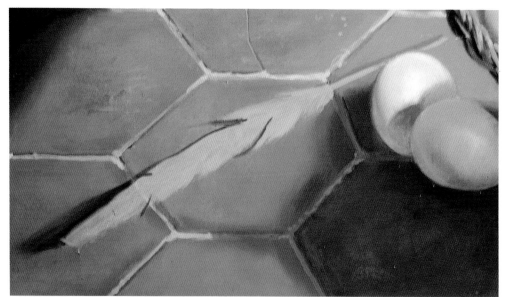

48

FEATHER

48. Over a thin layer of medium, I paint in a gray tone for the shape of a feather. Then, I paint in its cast shadow with a mixture of brown and black.
49. With mixtures of burnt umber and black grays, I paint in the color changes on the feather and indicate the divisions where the feathers split.
50. White highlights are added and softened with a blending brush.
51. Final touches to the painting include an additional feather and a fragment of onion skin. I also add a sprig of flowers to the foreground to help explain the flatness of the floor plane.

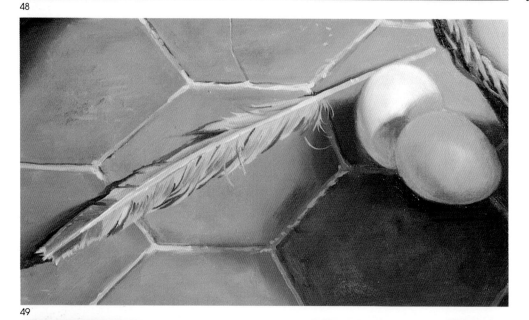

49

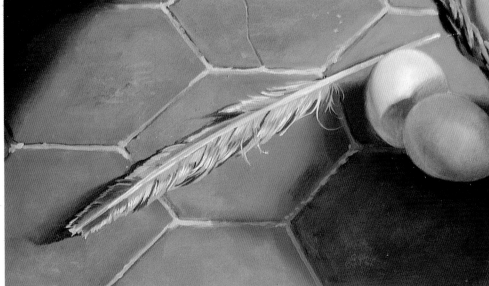

50

51

In order to establish a sense of depth
in a painting, objects must be
placed in the correct picture plane.

INDEX

Improve your skills, learn a new technique, with these additional books from North Light